SIGNAL:09
A Journal of International Graphics & Culture
Edited by Alec Dunn and Josh MacPhee

Signal:09 edited by Alec Dunn & Josh MacPhee
© 2024 PM Press—Individual copyright retained by
the respective writers, artists, and designers.

ISBN: 979-888-744-024-8 (paperback)
ISBN: 979-888-744-028-6 (ebook)
LCCN: 2023936721

PM Press, PO Box 23912, Oakland, CA 94623
www.pmpress.org

Design: Alec Dunn & Josh MacPhee

Cover image: Various artists, *Absolutes Denkverbot*
LP, Ka KKW Records, 1977. Frontispiece:
Outside Sangomauro demo at Fiat ca. 1969 by
Raffaele Santomauro; inset graphic by Anne Lund.
Background image on this spread is a puppet by
Pietro Perotti, made for a demonstration against
cuts to cost of living wage scales, Rome, 1984. Image
on following page spread: a selection of stickers
produced by Pietro Perotti.

Printed in the United States.

Thanks to everyone who worked on this issue.
Special thanks to everyone across the globe in the
streets for Palestine.

SIGNAL:09

SIGNAL *is an idea in motion.*

From the start, Signal has maintained an open-minded and open-ended approach to political art. Our first issue gathered a wide range of strategies: from playgrounds to graffiti to comics to prints. We have continued this tradition by choice and by necessity. Each issue ends up with whatever rolls in from contributors, and more often than not, we have to reach out and cajole people into writing. The table of contents often doesn't get finalized until we're already past deadline. Haphazard and accidental, our approach has spun a growing web of content—each article is on the map of politicized culture, but each comes from a different perspective. We chose the title *Signal* for its obvious metaphorical implication: a signal is something concise and directed, a pointed communication that spurs action, but *signal* is also a verb, an idea in motion.

Some ideas have remained throughout our existence, and here we state them again: We believe that culture plays a crucial role in social transformation and that cultural work not rooted in liberation reinforces the ongoing crisis in which we live. We continue to believe that the writing, studying, and making of political culture should be open to all—especially those involved in said social transformation—not just those credentialized within academia.

Social media has made it easier than ever to access the political culture of movements worldwide. At the same time, it is a terrible archive—amazing material everywhere one day and gone the next. It's excellent for sharing techniques but bad at teasing out motivation, context, and thought. When we started *Signal*, we wanted to carve out a space for clear-eyed and in-depth writing about the role and potential of cultural work in political movements, with a focus on sharing imagery, strategies, and aesthetics that challenge preconceptions of what political art could or should be. Fourteen years later, with nine issues under our belt, we believe more

than ever that culture is a key component of social transformation. At the same time, we've seen the idea of "The Power of Art" move from the margins to the lips of everyone from politicians to bankers. Now more than ever we must ask the questions of *what* role art plays in change and *how* that change happens.

We welcome submissions of writing on visual cultural production for future issues. We are particularly interested in looking at the intersection of art and politics internationally and assessments of how this intersection has functioned at various historical and geographical moments.

Signal can be reached at: signal.editors@gmail.com

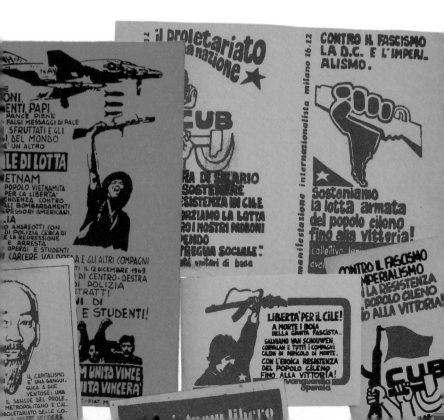

THEY HAVE CALLUSES ON THEIR TONGUES. WE HAVE CALLUSES ON OUR HANDS.

A DISCUSSION WITH PIETRO PEROTTI

WORKER
ARTIST
AGITATOR
PUPPET MAKER

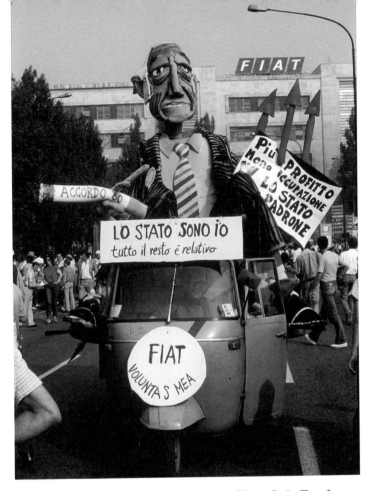

Pietro Perotti was a worker at the Turin, Italy, Fiat factory from 1969 to 1985. As a self-appointed representative of Fiat workers' communication, he created posters, leaflets, stickers, and a magazine. He drastically changed the approach to workers' demonstrations and pickets by introducing protest puppets and street theater. This interview focuses on his artistic strategies in support of the workers' struggle, the life lessons he learned after many years of being involved in the struggle, and the relation between the individual and the group.

Pietro Perotti: What will you do with this interview? I didn't understand what you need it for.
Davide Tidoni: I am interested in the link between art and politics in your creative work, like the contribution you brought to the workers' movement and how you contributed to the birth of new forms of protest and struggle. I am also interested in how you understand your own artistic practice within the wider social discourse that goes beyond simple self-expression. On a personal level, I want to know how you have balanced artistic self-expression and political commitment, how you inhabit your role as an artist, both inside and outside political struggles.

I'm interested in talking with you because you are someone who has done a lot but hasn't spoken that much, which is different to what seems to happen in many art contexts, where there is a tendency to privilege philosophical discourse. There is a certain fascination with theory, presented by people who often do not have much direct experience.

Well, they have calluses on their tongues. We have calluses on our hands.

Maybe let's start by saying a little about where your creative artistic spirit comes from.
I come from a town in the province of Novara called Ghemme. I was born in February 1939, then World War II broke out that September. No one in my family was artistically inclined. I only ever found a poem by my grandfather who had written something ironic about the blackouts that happened during wartime. When I went to school, the teacher said, "Make a drawing." All the others drew a lawn, a house, flowers. I drew a red devil. The teacher went to the headmaster to show him that I had done different things from the usual. She was nice, but the headmaster was a fascist military officer and he didn't like my drawing. He called my parents and I was scolded, so I stopped drawing. I have not drawn since then.

My first encounter with art was in the carnivals of '55 and '56 in my village. Farmers,

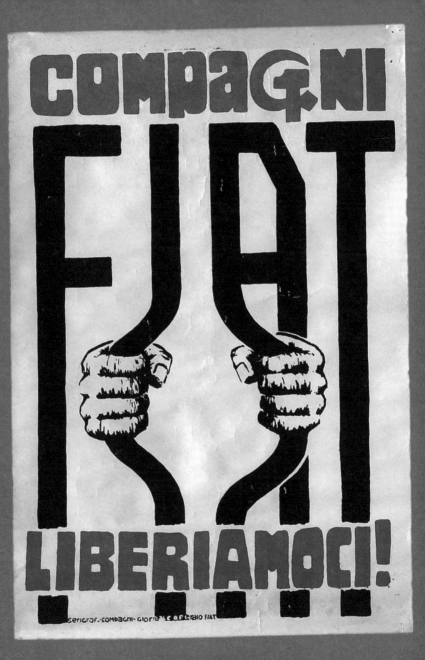

builders, workers made carts without having any artistic notion. We parish boys made a cart with flasks, wire, hessian fabric [burlap], and plaster. We didn't even know how to use papier-mâché. The important thing at the time was that the war was over. There was a great enthusiasm, a desire to get on with life and to participate.

Later, as a teenager in the parish, there were nativity scenes to be made, and I started making sculptures with clay. I also imitated Chaplin, did some skits, and made the scenery with cardboard.

Then one day I saw Dario Fo on the TV show *Canzonissima*. He did a skit about a builder who died, which had been censored by the broadcasters.[1]

Almost the same thing happened to me in '67–68. I worked in a factory in town, and I had thought of doing a skit making fun of the owner of the factory. I made the workers as if they were the pipes of an organ, and the owner directed them by whipping them. Then there was a choir that I called il Coro del Polveron (the Dusty Choir), because we worked in a textile factory. We worked with cotton and there was dust everywhere. The choir sang, "When the siren sounds / Be it winter or summer / Whether it rains or the wind blows / Let's go to work." Then the refrain: "In the middle of the dust / In the bales of cotton / In the middle of the dust / We are soaked in sweat." Then: "When the sun beats down / There is air conditioning / Coca-Cola and orange soda / Galli Gazzosa / Aniseed water." At the end of the song, we got panettone: "When it's very cold outside / We get hot from working / And on Christmas Eve / He gives us panettone."[2] One evening we were rehearsing, and the parish priest came and said, "Stop, you cannot do this. You must not make fun of the owner who gives you work." The owner was named Crespi. He was a bit like [Gianni] Agnelli.[3] He ran everything, he had three factories, the sports club, and the parish. So we were censored, and since then, little by little, I began to understand how things worked.

At a patronal feast in 1968, I presented *Judas '68*. It featured a skeleton with a lot of money in its hands, wearing half of a priest's hat and half of a

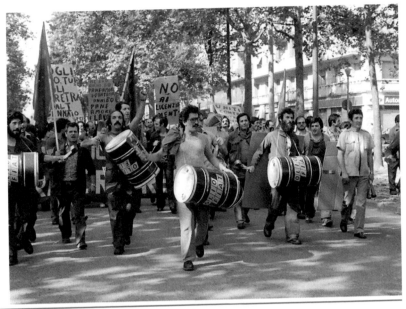

Fiat workers' protest, 1979. Photos by Raffaele Santomauro.

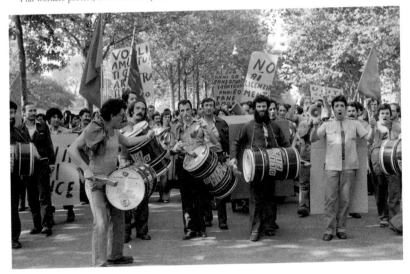

tall top hat, and a red handkerchief around its neck. This was because the Soviet Union had invaded Czechoslovakia.

The previous year I had presented works with found materials. A piece of wood from the mountains had become an atomized dog hit by the atomic bomb. Next I made a crucifix that became the *Christ of the Hopeless*, made with copper coils and hessian fabric. Like something by Calder. This Christ ended up here in Turin, where there was a dissenting Catholic priest who used to celebrate Mass in a garage. I gave him the crucifix.

Our political group in town was formed when we found out about *Lettera a una professoressa* (Letter to a schoolmistress) and *L'obbedienza non è più una virtù* (Obedience is no longer a virtue) by don [Lorenzo] Milani.[4] Those were our first political books.

But where did these artistic ideas come from? Was it all stuff you came up with by yourself?
Of course. I only completed primary school, and I tried to become more cultured a little at a time. When I arrived in Turin, I realized that the banners and flags were obsolete, and it was no good to see people who walked behind the demonstration without contributing anything personal. I believe in organization, but I also believe in the individual, in what each one brings in terms of creativity and innovation.

In Turin you noticed that the workers were following the demonstration with flags and banners but they had no other ideas—they did not know how to give these old forms new meaning.
There was no individual action. There was involvement, but no individual intervention. I started doing street theater because during the struggles over work contracts I saw mechanical workers employed at Mirafiori making coffins. Coffins for the dead, with "Fiat" and "Zaccagnini" written on them.[5] I thought this was grim, so I started making colorful things with cardboard, trying to make fun, using irony. I believe that irony is a very strong thing. It's not by chance that in Paris a few years ago they killed [Georges] Wolinski and the *Charlie Hebdo* guys. When I came to Turin in '69, I found

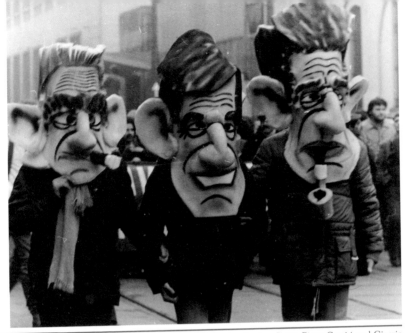

Above: Protest puppet heads of metalworkers union leaders Luciano Lama, Pierre Carniti, and Giorgio Benvenuto, 1982. Below: Gianni Agnelli (head of Fiat) puppet, at a metalworkers' demonstration over work contracts, Turin, 1979. Photo by Raffaele Santomauro.

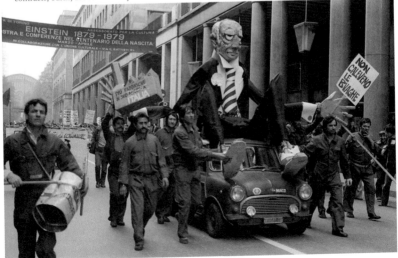

the first ten copies of *L'Enragé*, a magazine of political satire founded during the student revolts of May '68. Wolinski was the first of my teachers. Siné and Wolinski are two cartoonists who have strongly inspired me.

At Fiat I made a twenty-five-foot-tall Agnelli puppet that people carried around. Agnelli said, "We will not drop our trousers," but during marches workers would pull its trousers down, leaving the puppet in flowery underwear, and everyone would laugh. Neither the news nor the press have ever shown these things. It means that they hit the mark and the workers were amused. I tried to bring a little smile into that factory, a little joy. Now everything is clean, but back then it was a disaster, it was a wretched place.

You made "street theater."

Yes, it became street theater. People moved, and it became movement. It was a dynamic thing. I have always been in favor of dynamic things that were not static but that moved with the people. People participated in these things. It's not like you were alone in the back. Things moved around, especially when

we went to Rome on March 23, 1984, against the Craxi government.[6] It was the biggest demonstration in the postwar period, something never seen before. The CGIL [the Italian General Confederation of Labor, a national trade union] gave us a truck, and we went down with the structure that we built. There was a huge dragon that had Fanfani, Spadolini, Andreotti, and Agnelli on it.[7] Apart from that, the Craxi puppet was walking around with a sign saying, "I don't care about the streets" while all the people were laughing and cheering.

It seems to me that you had a need to express yourself creatively. You lived the reality of a worker and therefore you applied your creativity in the context of the workers' struggle, but if you hadn't had the creative drive, would you have approached the political struggle anyway or not?

I think so. Look, the idea of coming to Fiat was a political choice. I came to Turin because I thought that the revolution would start from there. I joined Fiat in '69, and whilst I was there, I joined Lotta Continua.[8]

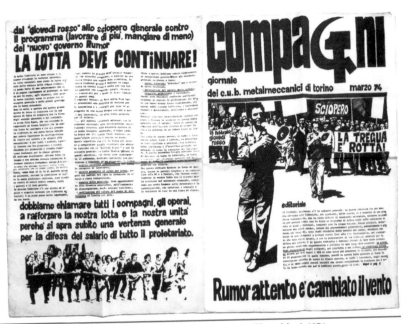

Compagni (Comrades), wall newspaper of the metalworkers of Turin, March 1974.

I thought their goal was to make a contribution, to develop workers' class consciousness. I had read [Antonio] Gramsci and his writings from the newspaper *L'Ordine nuovo* for a while. You know Gramsci's phrase: "Educate yourselves because we will need all your intelligence. Be excited because we will need all your enthusiasm." I thought the same, but while attending the meetings I realized that Lotta Continua was too spontaneous. They came, they heard the workers, and they told them, "Tomorrow, you have to strike." Some went on strike, but they weren't in a union and they weren't protected, and then Fiat fired them. So it was all a bit exploitative. I wanted to join an organization that would give me tools, so I joined Avanguardia Operaia[9] because they had made some publications and they also organized political training courses.

Then I realized that in these organizations, those who counted most were the line workers, because they could stop

the production line. I, on the other hand, didn't count for shit, because I had been lucky enough to be employed as a specialized worker. I asked my political leaders to give me a role, and they did. They sent me to do external interventions at Pininfarina . . . so I thought, "These here are all out of their minds. I have to find myself a place."[10] So I became a self-delegate, self-appointed to workers' communication. I started silkscreen printing stickers at home. I made them for everyone. Stickers about different themes, about police arrests, about repression, and they were very much appreciated. There are some beautiful photos of demonstrations with my stickers that people stuck to their clothes. Also the poetry written by the workers, ironic stories posted on the bulletin board inside the factories. Things done by the workers were the most appreciated, because they said, "Fuck, it's a worker who does these things."

Often leaflets came from Lotta Continua or from PCI [the Italian Communist Party] or PSI [the Italian Socialist Party], but they arrived already printed, already packaged; there was no creativity. I didn't expect Avanguardia Operaia or my union to tell me what I had to do. For example, when Giovanni Leone resigned, I heard the news in the evening on television and I immediately prepared a drawing of Leone leaving with a bag full of money.[11] He waved goodbye, and the title said: "Leone's last farewell to Italians. The receivers have received, and the givers have given. Let's forget about the past and not talk about it again." I made five copies, and I gave one to the press sector in the factory, two to the mechanics, and two to the body shops. Fifty thousand workers were around, and before evening everyone had seen them and no one tore them up. The message got through, immediately, without waiting for a group to organize a message. So I realized that I could have my say without being associated with any group.

Always your own personal initiative.

Clockwise from top left: *Il Manifesto* wall newspaper, 1978; "Agnelli, you have Indochina in the factory!," 1973; "Free Vietnam, Red Vietnam," 1973; "Wanted: Jesus Christ, revolutionary, extremist, anarchist . . .," 1968.

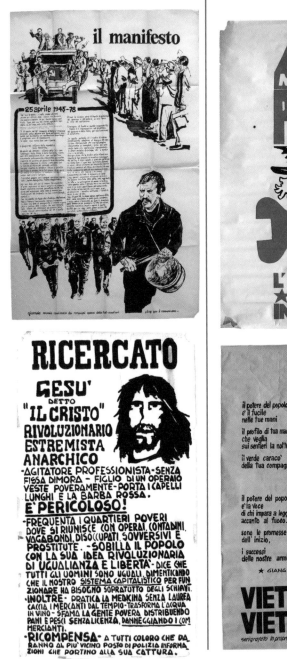
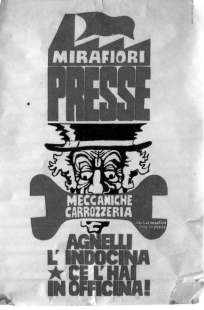

Then we understood, as Gramsci said, that we must educate ourselves, and so we made *Compagni*, a magazine written completely by the workers, where I also did the graphics. To keep it cheap, we had to change printers several times. The paper had to be ready before you brought it in to press, already prepared on glossy paper. You had to type it up, and the drawings were made with ink in black and white.

The formats and the techniques are also interesting: the stickers, the silk-screened posters, the newspaper . . .

May '68 in France led us to print the posters using silk screen. The creative, liberating, playful spirit of May '68 has accompanied me all these years. In the village we had made a silk-screened poster saying: "Wanted: Jesus, also known as Christ, the extremist revolutionary anarchist who turns water into wine, damaging local producers." One had been posted outside of the church.

But do you still see these people from your town?

Some yes, some are gone, some stayed but they didn't continue with politics. I had some problems because I was leading some protests. Nearby there was one of the largest waste dumps in northern Italy, which I fought against. During the carnival of 1987, I made a big performance where there was a huge mouse full of garbage, and the text said: "Field of miracles: in comes the waste, out come the billions." I made the mayor of my county look like Pinocchio, with a nose that stretched; the regional president of the Christian Democrats was the cat, and the socialist councillor was the fox. When the mayor talked in front of the crowds, he said, "There will only be 60 trucks of waste." Instead there were 120 and the nose kept getting longer. After this, things were a mess. They evicted us from our space—we had a private storage space for our materials, and they took that away from us.

Was this a structure or was it a poster?

A twenty-meters-long structure, a piece of street theater that moved around town during carnival. Everything was three-dimensional.

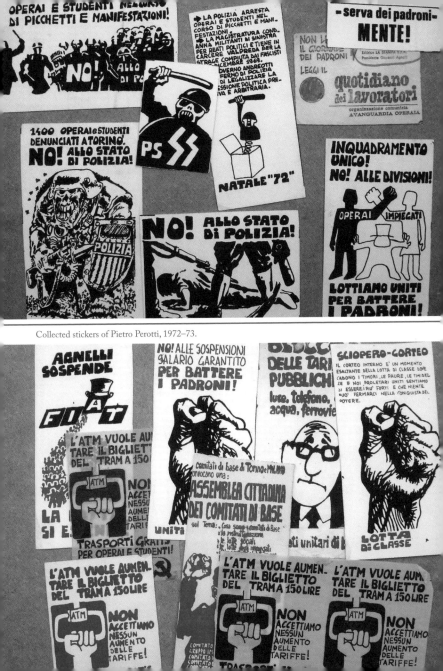

Collected stickers of Pietro Perotti, 1972–73.

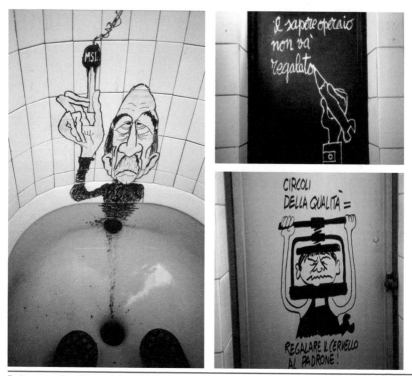

Bathroom graffiti at Fiat, including "Workers' knowledge should not be given away . . ." and "Don't give away your brain to your boss," 1985.

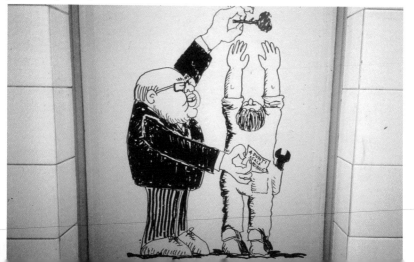

But when you did these things, how did the group of people who helped you form? Was it spontaneous or not?

In the village, there was a group of people who lent a hand. I was the one who gave directions, but then there was a whole series of people who joined to mobilize, to run the puppets. The same thing at Fiat. I made the Agnelli puppet in the trade union league, the fifth league of Mirafiori, but then it was the workers who carried it around.

Do you feel that people appreciated this kind of creative political expression? Did you feel it activated them?

Absolutely, but above all we were in tune. Nobody stopped me. This includes the painting I did of Marx in front of Fiat. Nobody asked me, "What are you doing?" It was accepted by everyone, I painted it there at the factory, right in front of door five. It's not like it was brought from outside.

When you hung the posters in the factory, was there a risk that someone would say something or not? Maybe not the workers but the guards.

Of course, especially when, years later, I brought in a camera to take pictures in the toilets. I wanted to document the writings made by the workers. Then, I also started replying to the messages that were left there. I have more than three hundred slides with the back-and-forth that was written in the toilets. The problem was that I had to wait until the water flushed in order to be able to take the photo.[12] You needed the sound of the water to cover the click of the camera, otherwise the guard heard the sound and found out. You always took risks. I risked being sued for "industrial espionage."

Were you the only one with that kind of sensitivity to the workers' self-expression? Strange how nobody else cared about this.

People wrote in the toilets but they didn't understand how important it was to document everything.

You had all these beautiful ideas, but did you ever want someone else to have them with you? Have you ever felt alone?

No, I never feel alone, because I'm supported by those who fought before me. There were the partisans, the comrades I met, there were the workers who fought and didn't have anything. I never feel alone because behind me there are all these people. I'd like to pass this knowledge on to someone. I would be sorry not to pass on some memory.

Do you consider this art, or is it politics? I believe that it is about life. Art and politics mean nothing if they are not related to life. One has certain skills and puts them to use in the area to which one belongs and in which one participates.

Sure, that's it. I put my knowledge, my experience, my resources to use. Artists are something else; artists create worlds, like Miró and Kandinsky. I did what I did because it was needed at the time.

But you had a certain creativity, a sensitivity of sorts. This led you to create images and situations that could create momentum, that shifted political discussions into different forms. You took responsibility for these things. You played a role.

Sure, everyone has to use what knowledge they have. Some were busy blocking the factory floor; others made musical instruments. There is one thing that I think is an important piece of design: a friend of mine made it, he was a superspecialized worker, and by folding a small sheet of aluminum he made a whistle, *fischia il tuo sciopero* (whistle your strike). Others made trumpets. We made *la macchina del rumore* (the noise machine). It was a big oil barrel. On top of it there was a kind of crank that turned some bolts so it made a hell of a noise.[13] Then others made the first drums.

The first unauthorized strikes started like this. Someone takes a barrel and starts beating . . . *tum tum tum* . . . others get together and look for more. A team goes on strike and tries to reach the other teams in the other sectors of the factory. Then you have to make yourself heard, you have to warn the others, make a mess. That's where the drums started.

GENNAIO 79

il manifesto

Il Manifesto wall newspapers, 1978–79.

ARGENTINA 78
dietro il "mundial"

il manifesto

Sistematica la tortura, circa 10.000 i prigionieri politici, per lo più detenuti a tempo indeterminato senza imputazione e "processo", almeno 15.000 persone "scomparse" nel nulla negli ultimi due anni: questo il quadro di un paese il cui governo si era esplicitamente impegnato a ristabilire impero di civiltà del governo.

Giustificata da parte del governo con la necessità di combattere terrorismo e guerriglia, questa violenza repressiva si dimostra attualmente quale è realtà: secondo dichiarazioni ufficiali la guerriglia è stata sconfitta. La vera realtà "quaniovo" e tortura non sono diminuiti.

Il presidente Videla ha dichiarato che "terrorista non è soltanto l'individuo con una bomba od una bomba, ma anche colui che diffonde idee contrarie alla civiltà occidentale e cristiana" (fin. trenta, Maggio 1978)

Roberto Guevara, fratello del "Che", in Italia a chiedere solidarietà
"la resistenza argentina dice:
"C'è gente con capacità per cento di sangue italiano nel nostro paese.
su un milione di abitanti, nove, in Argentina, sono italiani almeno d'origine
nella maggior parte operai. Per questo è consentito degli operai dei lavoratori italiani
che sono solidarietà più a tuo popolo. Tanto di fare concrete, non di dichiarazioni."

Ecco un esempio, il generale Massera, appartenente della Marina nella quale, il vendita in Italia per visitare una fabbrica d'armi.
Gli operai di Napoli di mettere fine, il boicottaggio alla vendita d'armi è un ottimo esempio di solidarietà".
Ma c'è dell'altro. Una sono meno di duemila di italiani dispersi o prigionieri nelle nostre carceri.

Onore qui esce e torturato.
Naturalmente anche quelli italiani
Sembra che le armi fattati con loro.
Esse adeguate compagne, di stampa.
Soprattutto divulgare dalla consentivo che approfondire la realtà del nostro paese..."

Sosteniamo la resistenza del popolo Argentino
contro il fascismo e l'imperialismo
internazionalismo proletario!

P.D.U.P. per il comunismo

Internal strikes with demonstrations did not exist before. They were brought by southern immigrants. Before the southerners arrived, striking was about staying still in the workplace. If there was any need to go out, we went out, but the idea of the internal strike that moves around and forces the scabs to join in was born after '69 when mass hiring began.

Why the southerners?
My understanding was that the southerners had the patronal feasts in their DNA, that mix between the sacred and the profane. Some of them even put on a bishop's hat. It became a kind of procession. Instead of the cross, they carried a broom around with work gloves on. It was like a ritual, and Romiti[14] called us "those of anarchy and carnival."

It was about having fun.
Of course. In the morning, on the tram, on their way to work, they were all sad and sleepy. Then inside, when a spontaneous strike started that was not foreseen, there was this sense of freedom . . . this burst of new energy. Inhibitions were abandoned. People started doing things they had never done before. They started singing "Figli dell'officina,"[15] and we hugged each other. When we managed to break through, arriving in other sectors, from the presses to the mechanics, uniting all these people, it was unique. That was a time when the workers felt free to express themselves.

The role of emotion is important, this charge that you feel when you are together with others. You can carry on the political and artistic discourse because you are with people. That's what mobilizes you. You do things not only for yourself but for those who are there with you. You do them because you are able to set in motion this circle of human contacts that gives you support and carries you forward.
Absolutely. All the things I've done in those years have never been signed. They belong to everyone. Everyone does what they are capable of doing. Everything is not an end in itself; it is always aimed at something. It is an action and not a finished object.

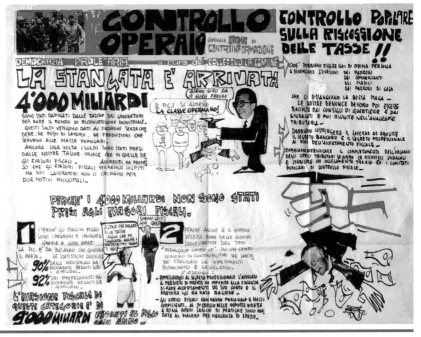

Controllo operaio (Workers' control) wall newspaper, 1970s.

I wanted to ask you about Radio Lotta, the pirate radio organized during the pickets and the block of the factory in the autumn of '80.[16] It wasn't really a radio. We had an audio system installed on my Fiat 500. I was driving around the pickets and the gates with updates.

A radio newspaper.

We recorded the messages, and then we played them back so people could hear what had happened. It was mostly political news on the negotiations in Rome.

Bear in mind that there were already free radios at that time, but they didn't broadcast nearby. If free radios had given us the opportunity to broadcast directly . . . but in the '80s we were isolated. Most of the intellectuals had already abandoned us. There had been the whole thing about terrorism. We got to the '80s and it was just like when we were alone in '69.[17]

A big opportunity to collect stories was lost in those thirty-five days we blockaded the factory. Marco Revelli did something. He recorded the people who stood there and sang. That was a moment when people had the time to tell stories. You could collect stories of people from the south who had occupied abandoned lands in the '50s. There were former partisans. There was one who had kidnapped Valletta.[18] There was a whole series of stories to tell and to be collected. But nobody came. Not even any film directors, neither those from Turin nor those from Rome.

Roberto Buttafarro—a friend of Marco Revelli—did something. In the evenings we created a counternews program with the footage he had shot during the day and showed it at the coordination center in front of door five.

Revelli and I then made a book in 1985, *Fiat autunno '80 per non dimenticare* (Fiat autumn '80 so as not to forget), where we tell things day by day. There is a cassette and a book, and the sound is exceptional. It is very evocative, especially during the evening pickets.

I did what I could with an eight-millimeter film camera. Unfortunately I couldn't shoot in the evening, because the film was not sensitive enough. And the film was expensive, and only lasted three and a half minutes, and I had to wait a month to see them because they were developed in Germany. In those thirty-five days, I spent what little savings I had all on film.

Let's talk about the documentation. You always kept track of the things you did. The posters, stickers, stencils, magazines. When you joined Fiat, you also started filming strikes and pickets, your protest puppets, writings and drawings in the toilets. I had understood for years that if you aren't documented, you don't exist. My things are all documented except *Judas '68*, because it was censored too soon and I didn't have time to photograph it.

The shocking thing is that neither the union nor the PCI thought about the documentation. If you want to transmit history, you have to document it. Images are important. So much so that in Auschwitz when the Russians realized that people would not believe what had

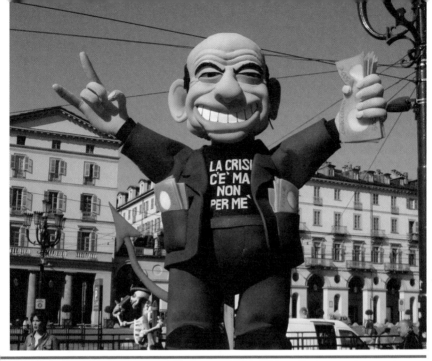

Above: Silvio Berlusconi protest puppet, May Day 2009. Below: Umberto Bossi puppet, demonstration against regionalist party Lega Lombarda, Milan, 1997.

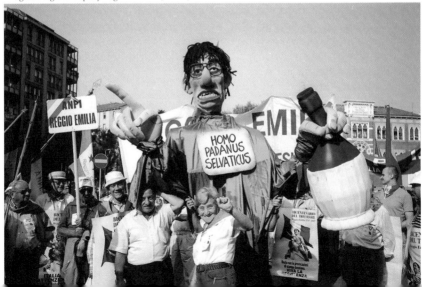

happened, they put people back there to film them; people were filmed the next day. You can write a lot of books, but there are images that have to speak for themselves.

Where did this awareness of documentation come from?
When I was in my hometown, I lived opposite a photographer. I was impressed by the magic of the photograph, the strength of capturing a moment. And then as far as cinema is concerned, I had a teacher in town, Renzo De Vecchi. He bought a movie camera in installments in the '50s and filmed the carnivals of '55 and '56. What a surprise when people in the town saw each other again in the film being shown. These are things that remain. That's where I understood that if you want to transmit a memory, you need images.

Also, to be able to say, "This happened. It is not fiction." As long as the images remain, they cannot be deleted.

And after you quit Fiat?
I went on. I continued with three-dimensional things. I had learned how to use foam rubber

from Piero Gilardi, the visual artist. He did free protest-puppet workshops at the pickets in the '80s. I made my first things out of foam rubber in '82 when Stefano Benni came to do Circo Italia [a mobile Italian circus] for former Fiat workers who had been put on furlough.[19] On that occasion, I made puppets of trade unionists Lama, Carniti, and Benvenuto in their underwear and then l'Elefante Spadolone (Spadolone the Elephant), who was actually Prime Minister Giovanni Spadolini; il Nano Fanfani (Fanfani the Dwarf); and then there was il Gorilla Pietro Longo (Pietro Longo the Gorilla). They were all political figures. After I quit I got a VAT number.[20] I worked for Radiotelevisione Italiana, for all of Benni's scenographies, and then I did an opera, *L'enfant et les sortilèges* (The child and the spell), with Altan at the Teatro Massimo in Palermo. Then I put together a catalog with all the sculptures I made for Altan, which was called *Mondo babonzo, museo delle creature immaginarie* (Babonzo World, museum of imaginary creatures). It was a book for Gallucci editore. He usually makes good books, but this one didn't turn out very

well. He wanted to do it quickly so he could sell it for Christmas.

Gilardi, how did you meet him?
He was part of my own organization.

You met outside the factory?
We did external interventions: leafleting in front of the factories. Then we worked together, and after that we did a lot of things together. After I quit Fiat in 1985, I could not go into retirement, so I worked with him.

What differences do you feel you have compared to him, who also does things in museums?
My art is social art. All my research is independent and free; it cannot be commodified, and it is usable for free by all. The things I have done are not in a museum anywhere. It is an art that crosses culture, from top to bottom. It enhances the role of those who build their own destiny with their own hands and try to improve the society in which they live.

Do you ever want to do something unrelated to the social dimension? Something that maybe you keep for yourself?
No, not so much.

You mention building all these puppets and street theater props, putting on operas, et cetera. How was all this funded? Some of these things must have been somewhat expensive to pull together. What are the economics of this?
Everything was self-financed. I understood that being autonomous gave me the ability to express my ideas in an original form. The puppets, the posters, the stickers, the films, even the Marx I painted at Mirafiori, it was all my own money. In the early 1980s, what little savings I had, I used it all to buy film and material for documenting the struggles. The *Compagni* newspaper was prepared with the money collected from the workers. Then we sold it so there was money to pay for printing the next issue. Only once did I get money from the

union. It was for the demonstration in Rome against Craxi. The union provided a truck to transport the puppets from Turin to Rome. After the demonstration, the union sent a check as a reimbursement for the materials I used for making the puppets. With the money that was left, we all went to dinner.

The puppet show Stefano Benni did at Mirafiori had also been paid for by the union. The interesting thing was that, without telling Benni, I changed the ending of the show. I made the puppets of the union secretaries come out onstage in their underwear. This was not planned, and Benni got angry. According to him, because the union was financing it, we could not make the union leadership come out in their underwear. I told him, "Listen, I'm a delegate and I'm the one who takes responsibility for making fun of the union secretaries." Except for these two times, it was always my own money.

What have you been doing more recently?
Now I have a workshop in Turin. We have done a lot of things with the association Volere la Luna (Longing for the Moon). We have participated in all the biggest demonstrations with the Sardine—those against Matteo Salvini, on May 1, all the demonstrations—without being tied to any particular organization.[21] With the Sardines I made a puppet of Salvini's head with sardines swimming around him.

Many were quite disgusted by the Sardines—as they were limited to a generic critique of the right wing—and instead you went to the streets with them.
Absolutely, we do everything that moves. I do this because I can have my say. Here there is always someone more to the left than you, and when you worry about that, you don't go anywhere, you just keep dividing.

But you still maintain your individuality even when you join others. You found your way to express yourself, even at Fiat. You did not think in the way that the groups or organizations wanted.

Never . . . never. Over the years the thing that saved me was this anarchist foundation that allowed me to think for myself,

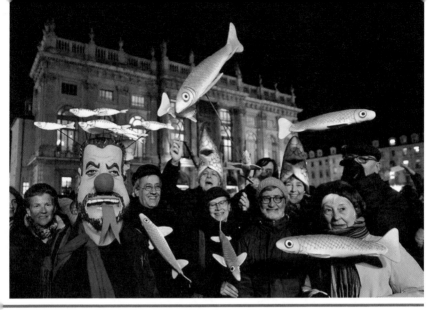

Demonstrations against Salvini, together with the Sardines, Turin, 2019.

not to create myths, not to follow trends. If I had listened to the union and the groups to which I belonged, I would not have done any of the things I have done.

I guess this has brought you into conflict with the groups you have worked with. If you went to meetings, you most likely clashed with others, but you remained internally strong. How did you not get discouraged and give up?
As I told you before, you are never alone. There are those who were there before and those who will be there after, hopefully.

Do you think you were given more leeway or freedom to organize autonomously by the more organized political groups (PCI, the unions, Lotta Continua) because you were working in the area of "culture" instead of straight politics? In other words, was the art invisible to the political parties, so it flew under their noses without much intervention?
Sure. On one hand you can say I had this freedom because the political groups see much value in what I was doing. However, the most important thing that allowed me to act freely was that I had the support of the workers. My work was not culture coming from the outside. My work was accepted because I was doing it from within. Everything I did, I did it from inside the movement. I was in tune with the workers. They received what I was doing, and they were proud of it. They would say, "He is a worker. He is one of us." Think of the painting of Marx. I did it in front of the fifth gate of Mirafiori without discussing it with anybody in advance. I didn't bring it from home already done. At home I only sketched it, and then I painted it on site, with all the workers around approving of what I was doing. My work was accepted by the workers before being accepted by the political groups. §

A version of this interview was previously published in Davide Tidoni's *Where Do You Draw the Line between Art and Politics?* (a.pass, 2021).

Pietro Perotti in front of the Fiat factory in Turin, 1980. Following page: Protest at Cameri air force base during the Gulf War, 1990.

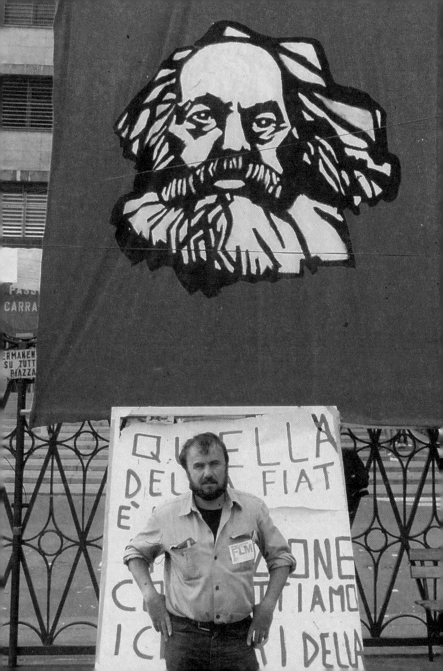

NOTES

1 Later, in 1962, Dario Fo was forced to step down from RAI, the state broadcasting system.

2 The melody of the song is from De Sica's film *Il giudizio universale*.

3 Gianni Agnelli, head of Fiat, was one of the richest men in modern Italian history.

4 Don Lorenzo Milani was a radical priest, defender of conscientious objection, and critical educator. His book *Lettera ad una professoressa* served as a manifesto in the struggle for reform of the Italian educational system.

5 Benigno Zaccagnini, one of the founders of the Christian Democracy party.

6 The Craxi decree brought cuts to the sliding wage scale, a mechanism that automatically adjusted wages to the cost of living.

7 All prominent Italian statespeople and industrialists.

8 A far-left extraparliamentary organization founded in 1969 by the student-worker movement of Turin.

9 A far-left extraparliamentary organization founded in 1968 in Milan.

10 External interventions consist of actions done outside the factory gates and not inside, like handing out leaflets or speaking into a megaphone.

11 In 1978, Leone stepped down from the presidency of the republic because of the Lockheed military aircraft scandal. The American firm admitted it had paid bribes to defense ministries and prime ministers of several countries, including Italy.

12 The toilet was automatic; it would flush every five minutes.

13 This was done with the workers in the press sector. The press was the noisiest sector, and these workers took their condition to the outside, so what they did was always noisier.

14 Cesare Romiti, Fiat executive since 1974. In 1980, he was the one who proposed to the unions to furlough twenty-four thousand workers.

15 *Figli dell'officina* (Sons of the factory floor), a song from the repertoire of the Arditi del Popolo, an Italian militant antifascist group founded at the end of June 1921 to resist the rise of the National Fascist Party. The song has also been used by partisans during World War II.

16 In September 1980, workers blocked the gates to the Mirafiori factory, setting up a picket in front of the gates in response to the proposals to furlough twenty-four thousand employees. Furlough was being used as a way of removing the representatives of factory councils and the more politically exposed workers from Fiat. The picket line continued for thirty-five days, until union secretaries from CGIL, CISL, and UIL (Lama, Carniti, and Benvenuto) settled for a compromise with Fiat, which would see all furloughed workers come back to work in the summer of '83. Fiat did not keep up its end of the deal.

17 In '79, Fiat fired sixty-one workers who were suspected of being aligned with terrorist groups. Beyond the question of whether or not they were in fact aligned, it's worth pointing out that terrorism was being used as a straw man to target and demonize protests around labor and culture.

18 In 1948, the manager Vittorio Valletta was kept hostage for a few days by several workers inside the Fiat factory. The action was a response to the attempted murder of Togliatti, leader of the Italian Communist Party.

19 A coordinating group for furloughed workers was set up to stay close to those who had been put on furlough. Aside from being a thorn in the side of the union, it also organized supporting activities, like assemblies, demonstrations, and meetings. The forced interruption of work caused several crises of depression among furloughed workers. Between '80 and '84, 149 workers committed suicide.

20 A VAT number is a tax identification that can be used for self-employment.

21 The Sardines was a grassroots political movement that began in Italy in November 2019. It was a popular front organization with the aim of preventing a right-wing victory in the January 2020 election. It formally ended in May 2020.

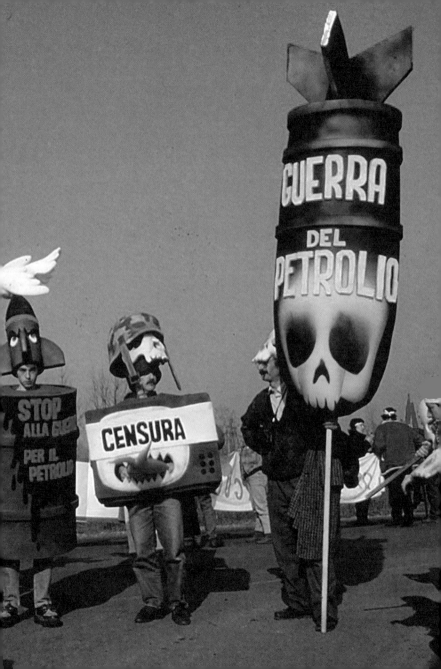

CREATIVE FREEDOM BEHIND THE IRON CURTAIN

BY AARON TERRY

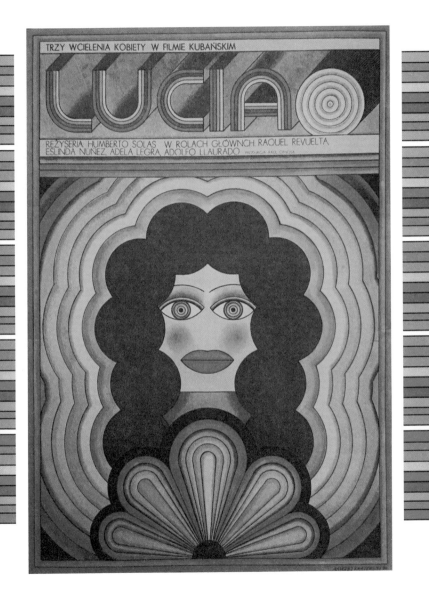

an Lenica's 1964 poster design for a Polish staging of Alban Berg's opera *Wozzeck* caused an immediate uproar. The poster, depicting an open, screaming mouth in the center of a faceless head amidst waves of red, successfully matched the terror of the opera's theme—people striving for dignity in the face of abuse and brutality. And it stood in graphic opposition to socialist realism by conjuring the remixed psychedelia of art nouveau's countercultural messaging (if not Edvard Munch's painting *The Scream*). The image on its own was ripe for interpretation, the oppressive redness of it: Was it blood? The Soviet flag? Communism? All of the above? In the face of state opposition, the original poster design was ultimately *not* printed at the time, but it did win the gold medal at the first International Poster Biennale in Warsaw in 1966 and would go on to become a symbol of rebellion during the Solidarność workers' protests in Poland in the 1980s.

Lenica's poster is one of many artistic subversions that pushed against totalitarian rule in the countries of the former Eastern Bloc. Beginning in the 1930s in the Soviet Union and continuing up through the mid-1970s, the primary acceptable style of art in socialist Eastern Europe was socialist realism. It was an idealized, hyperrealist aesthetic that depicted communist values: the emancipation of the proletariat, the dignity of labor, and social equality. Socialist realism's stock of motifs was fairly limited: images of famous revolutionaries exhorting crowds, a Soviet soldier staring across bountiful fields of wheat, workers completing a heroic task. However, throughout the twentieth century, artists pushed against these boundaries. Of note is a generation of poster artists from Cuba, Czechoslovakia,

Previous page: Andrzej Krajewski, *Lucia*, 1970. Opposite: Jan Lenica, *Wozzeck*, 1964.

TEATR WIELKI

ALBAN BERG WOZZECK

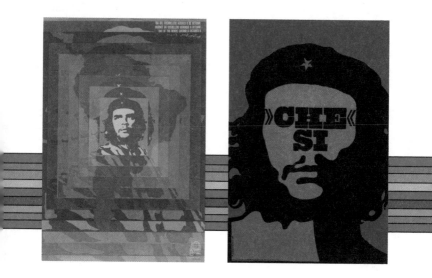

and Poland who created a stunning body of work that subverted
state control and bureaucratic views of socialist aesthetics.

In order to get to the meat of the subject of creative free-
dom behind the Iron Curtain—the political boundary that divided
Eastern and Western Europe—it's necessary to give some historical
background on the time. The Cold War was a fifty-year period of
ideological, economic, cultural, and military conflict between the
Soviet Union and the United States and their respective allies that
lasted from the end of World War II until the disintegration of
the Soviet Union in 1991. To the east were countries aligned with
the Soviet Union (some fourteen states including Poland, East
Germany, and Czechoslovakia), and to the west, countries aligned
with the United States (most of Western Europe, the United
Kingdom, Canada, and much of the Americas). An exception in
the Western sphere of influence, Cuba would be the only country in
the Americas to formally align with the Soviets after Fidel Castro's
26th of July Movement came to power in 1959. (By 1960, Castro
had signed commercial agreements with the Soviet Union to bol-
ster the island's economy.)

Although carried out in the name of the people, the communist

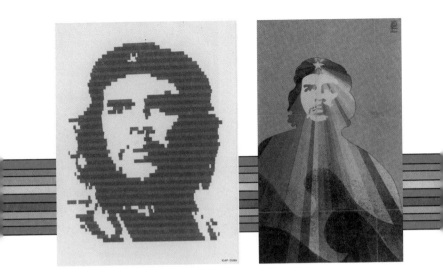

revolutions in Russia and Cuba did not occur without political repression. In the Soviet Union, conservative estimates show that at least 3.3 million people died directly as a result of Stalin's ruthless suppression of his political rivals and at least 14 million people passed through the infamous gulags, labor camps used as a means of political repression. In comparison, repression in Cuba was mild—yet the fear of repression and of state expropriation led tens of thousands of middle- and upper-class Cubans to flee the country.

After the death of Stalin in 1953, a political thaw took place under the Soviet leadership of First Secretary Nikita Khrushchev. During this time, the repressive policies and censorship of the Stalinist regime were relaxed, allowing for a period in which the Soviet Bloc opened up to more international trade, including cultural and educational exchanges of literature, art, music, and film, as well as sports. This opening of trade in turn introduced international influences to many artists throughout the region.

Cold War propaganda could be seen in numerous formats

Left to right: Helena Serrano (OSPAAAL), *Day of the Heroic Guerrilla Fighter, October 8*, 1968; Roman Cieślewicz, *"Che" Si*, 1967–68; Félix Beltrán, *Che*, 1967; Alfredo Rostgaard, *Che*, 1969.

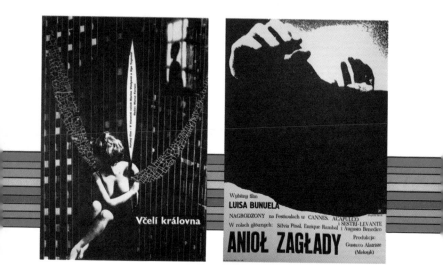

on both sides of the Iron Curtain: film, posters, comics, sports, books, and TV all touted anticommunist or anticapitalist messages, depending on your global location. By the 1950s, the US tended toward a more soft-power approach, exporting cultural forms that embodied an expressive sense of freedom (for instance, CIA and State Department funding of abstract expressionist painting and sponsoring of jazz music). The USSR, in contrast, attempted to control cultural output with a heavier hand.

It is easy to see programs of creative visual propaganda mirrored between the East and West during this time. While commercial interests tended to celebrate visual diversity in the Western sphere, the Soviet-aligned countries dictated erratic levels of censorship, which overall chilled any sense of creative freedom. Socialist realism was the official style allowed under the Soviets (with the exception of Cuba), and while all the satellite and Soviet Bloc states produced work in different languages and with different local concerns, cultural production was both directly and indirectly influenced by the pronouncements and cues of the Soviet GLAVIT (General Directorate for the Protection of State Secrets in the Press).

Given this overt and covert repression, it is interesting that in

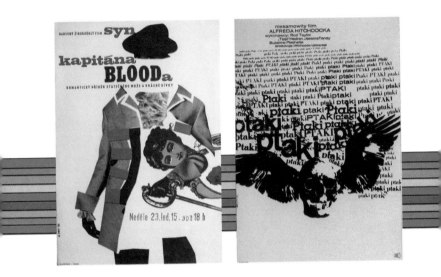

the Sixties and Seventies—when the Cold War and its propaganda was at its hottest—an intensely creative poster culture began to flourish behind the Iron Curtain. Capitalist histories argue that this was due to the pervasive and seductive influence of Western culture—the aforementioned State Department's cultural programs, Elvis and the Beatles floating out over shortwave radio, the seductiveness of American blue jeans. Less remembered are the forces within the Soviet sphere that attempted to course-correct socialism and pushed for increased liberalization. De-Stalinization—the removal of hardliners, the incomplete dismantling of the gulag system, and erratic periods of cultural openness—began in the late 1950s throughout the Eastern Bloc. The 1968 Prague Spring in Czechoslovakia was a landmark event that called for rapid economic and political democratization, including opening up restrictions on the media and free speech. These sentiments were shared in neighboring Poland, but by the end of the year, they were met with crushing military repression and occupation by Warsaw Pact troops sent by Moscow. (Soviet

Left to right: Ladislav Dydek, *The Conjugal Bed*, 1966; Joanna Krzymuska-Stokowska, *Exterminating Angel*, 1962; Zdeněk Palcr, *Son of Captain Blood*, 1964; Bronisław Zelek, *The Birds*, 1963.

Zdeněk Palcr, *Moral 63*, 1965.

control would remain intact until the Velvet Revolution in Czechoslovakia and the fall of the Berlin Wall in 1989 and the rapid dissolution of former Soviet states thereafter.)

In the former communist countries, poster art was a relatively cheap and effective form of internal propaganda. These state-produced posters graced classroom walls and workplaces, and for the more accomplished designers, their work often hung in people's homes. Poster artists were known and celebrated, perhaps nowhere more so than in Poland, which in 1968 opened the first museum in the world dedicated exclusively to posters. In 2019, I was fortunate enough to visit the Muzeum Plakatu w Wilanowie (Poster Museum at Wilanów) on the south end of Warsaw along the River Vistula, a museum that houses an immense number of posters spanning the late history of the Soviet Bloc. Beginning with a collection of Polish posters rescued from the ravages of World War II, the collection grew to include material from across the spectrum of the Soviet Union's sphere of influence during the Cold War. This allowed me to look deeper into this vein of visual liberation struggling under authoritarian rule. Strangely enough, this graphic bloom would happen primarily through the creation of film posters (albeit through a limited number of approved films to be shown in their respective countries).

When I visited the Muzeum Plakatu, on view was the exhibition *Breaking with False Myths?*, organized by the museum's curator, Jacek Szelegejd. It presented a visual investigation and comparison of the political and cultural output of posters during the 1960s and 1970s of Polish, Czech, and Cuban poster artists. I was able to spend a few days visiting with Jacek, asking questions, exploring the expansive archives of the museum, and attending the inauguration of the exhibit. On view were

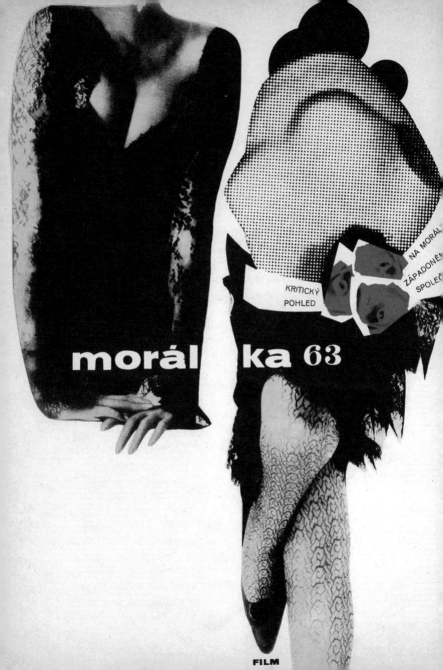

morál ka 63

KRITICKÝ POHLED

NA MORÁL
ZÁPADONĚ
SPOLEČ

FILM

Antonio Fernandez Reboiro, *Moby Dick*, 1968.

works by artists and designers including Poland's Mieczysław Wasilewski, Eryk Lipiński, Franciszek Starowieyski; Czechoslovakia's Milan Grygar, Ladislav Dydek, Zdeněk Palcr; and Cuba's Eduardo Muñoz Bachs, Raúl Martinez Gonzalez, and Félix Beltrán, to name a few; there were more than eighty-five artists represented in the show!

Political posters made up half of the exhibit: bold, iconic images of Che Guevara, Karl Marx, Vladimir Lenin, and Fidel Castro imploring the viewer to smash capitalism, conserve electricity, or join in cane harvesting in the name of revolution, promoting the work of all toward a common goal. The other half of the exhibit had posters on various subjects, some for past poster biennials themselves, but the majority were for the cinema. While the choice of films were technically subject to the approval of the central Soviet Politburo, the visuals for the film posters were generally left to the artists to create. Among these film posters was a

vast array of graphic styles and influences that conflicted with much of the hard aesthetics of socialist propaganda.

As Jacek described to me, some films and directors came in and out of favor of Soviet censorship, especially Western films. Avant-garde filmmakers, such as Federico Fellini or Luis Buñuel, were generally accepted and permitted to be distributed, as they often presented left-wing views or sympathized with left-wing movements at the time. However, any directors who were found to be critical of the Soviet Union might find their works subject to periodic bans throughout the entire communist bloc, or selectively banned from certain countries.

As the films were practically guaranteed attendance by the mere fact that they were foreign films and thus represented a rare glimpse of life beyond the Iron Curtain, Polish, Cuban, and Czechoslovak poster designers didn't need to advertise a film and thus often allowed themselves to take a more creative

approach. Jacek noted that the Polish poster artist Cyprian Kościelniak described the creative process as creating images that were made "halfway": the designers would create the poster designs that were open-ended in form and content as the first half of the design, leaving the second half of the design up to the viewer's interpretation of the image. In this way, artists were able to subvert and work around potential censorship. The opportunity to play with metaphorical design gave the artists camouflage and the freedom to work creatively. Additionally, some films would be shown two to three years after their release (more commonly in Cuba than in Eastern Bloc countries), so the designers were afforded the chance to create wholly new approaches to the films' original advertising design.

As Susan Sontag writes in the introduction to *The Art of Revolution: Castro's Cuba, 1959–1970*: "A beautiful poster made for the showing in Havana of, say, a minor movie by Alain Jessua, every performance of which will be sold out anyway (because movies are one of the few entertainments available), is a luxury item, something done in the end for its own sake. More often than not, a [film] poster by Tony Reboiro or Eduardo Bachs amounts to the creation of a new work of art, supplementary to the film, rather than to a cultural advertisement in the familiar sense."*

In this way, we begin to see how artists in Cuba were liberated from the propaganda needs of political posters and left to create with a free hand and a new perspective.

In some instances, there were posters created by two or three artists in completely

*Dugald Stermer, *The Art of Revolution: Castro's Cuba, 1959–1970* (New York: McGraw-Hill, 1970).

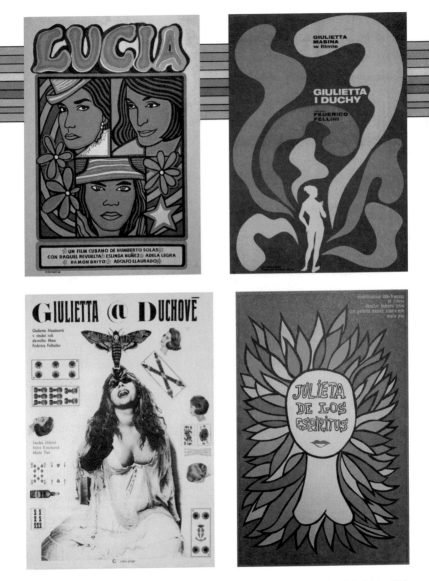

Clockwise from top left: Raúl Martínez González, *Lucia*, 1968; Eryk Lipiński, *Juliet of the Spirits*, 1968; Antonio Fernandez Reboiro, *Juliet of the Spirits*, 1965; Milan Grygar, *Juliet of the Spirits*, 1965.

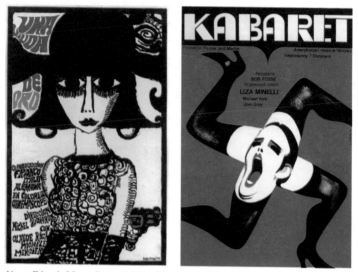

Above: Eduardo Muñoz Bachs, *A Golden Widow*, 1969; Wiktor Górka, *Cabaret*, 1973. Opposite: Jan Sawka, *The Canterbury Tales*, 1976.

different stylistic detail for the same film, such as the 1968 Cuban film *Lucia*, interpreted by both Raúl Martínez González (in Cuba) and Andrzej Krajewski (in Poland). Another example is director Federico Fellini's *Juliet of the Spirits*, designed by Antonio Fernandez Reboiro, Milan Grygar, and Eryk Lipiński, respectively from Cuba, Czechoslovakia, and Poland. Each example in *Juliet of the Spirits* takes on a completely different rendered approach, from the expressive, colorful, hand-drawn rendering of Reboiro to Grygar's largely black and white photomontage to Lipiński's simple, typographic poster with cut-outs of color surrounding a central figure.

Film poster design was able to flourish as a means of creative freedom outside of the state propaganda machine and was one of the few areas completely free of the visual trappings of socialist realism. This freedom did not come without its creative consequences. Many Cuban artists accused Eastern Bloc artists of being condescending. Local

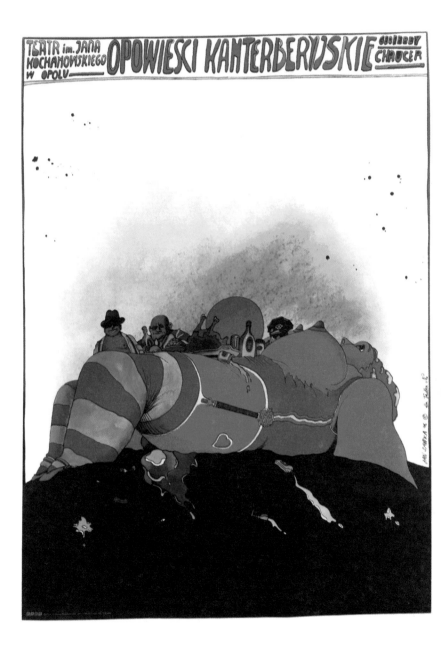

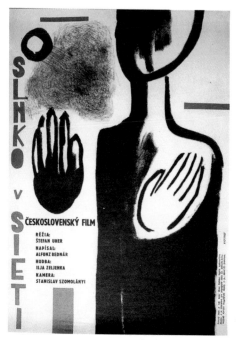

ČESKOSLOVENSKÝ FILM

RÉŽIA:
ŠTEFAN UHER
NAPÍSAL:
ALFONZ BEDNÁR
HUDBA:
ILJA ZELJENKA
KAMERA:
STANISLAV SZOMOLÁNYI

historical and cultural visits between Cuba, Czechoslovakia, and Poland were limited, but there were occasions in which the artists mingled. Cuban artists were on occasion invited to study or work in Poland, and they were known to publicly condemn Polish artists such as Wiktor Górka, Waldemar Świerzy, and Bronisław Zelek for their inference that Cuban artists lacked global historical and cultural knowledge due to their "isolated" island origins.

Many artists also fled their respective regimes in search of creative, political, and personal freedom. Tony Évora (Cuba), Roman Cieślewicz (Poland), and Wiktor Górka (Poland) all were "afforded/granted" permission to travel but ultimately fled in search of political and creative asylum from their respective governments. For some artists, the process of poster-making afforded freedom enough on its own. Antonio Fernandez Reboiro (Cuba) wrote: "Each poster provided me the opportunity to use a new formula, and all were a way of 'opposing' the established order. I've always believed that a poster is a piece of paper that shouldn't betray the story of the movie. Nor should it serve to advertise and encourage anyone to go

Above: Milan Pasteka, *The Sun in a Net*, 1962. Opposite: Zdeněk Palcr, *Courage for Every Day*, 1964.

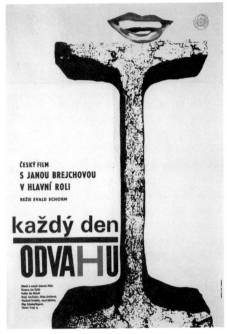

to the cinema, it is only decoration. That's how I have always designed them. Each poster I designed was completely different in approach to the previous one."*

While some posters from Poland and Czechoslovakia stand out simply in their abstraction, others went further with veiled criticism of the communist authorities. In 1976, Jan Sawka's poster for Chaucer's *The Canterbury Tales* was one of the last published before he was banished from Poland for his political views in opposition to the government. The poster depicts capitalist lust: the food, booze, and overindulgence of men eating on top of a sprawling female figure. The style presented is one of surrealist pop (à la the Beatles' *Yellow Submarine*) flying in the face of preferred style guides of the communist regime. It was unclear if the figures represented were actually capitalists or the communist leadership enjoying capitalist desires (at the expense of the Polish public).

Leading up to the Prague Spring, it was not only the posters but the films themselves that began to speak out against the repressive regime. Štefan Uher's *The Sun in a Net* from 1963, a landmark film

*Jacek Szelegejd et al., *Odkłamywanie mitów?*, exhibition, Muzeum Plakatu w Wilanowie, Warsaw, 2019.

of the Czech New Wave, presented numerous unacceptable social and political subjects, as it follows a teenage couple who, separated by a summer of forced work in a labor camp, pursue other romantic interests. Back home, the protagonist's father conducts his own extramarital affairs. Hardly didactic, but the film's negative view of collective work and exploration of modern alienation was a shot across the bow aimed directly at socialist realism. Subsequent films of the New Wave made increasingly direct challenges to the state socialist status quo. Evald Schorm's *Courage for Every Day* from 1964 depicts a young worker's fervent communist ideals as increasingly detached from his miserable environment. Themes of individualism, idealism, and disenchantment pervade the film. Miloš Forman directed *The Firemen's Ball* (1967), a satire about a bumbling small-town fire department and a thinly veiled criticism of communism and corruption in Czechoslovakia. This film forced him into exile, where he continued his film career and directed *One Flew over the Cuckoo's Nest* in the US in 1975.

Finally, to end on a piece that falls outside of film poster design, is the 1975 poster *To be (war) or not to be?* by Mieczysław Wasilewski. Designed to mark the thirtieth anniversary of the end of World War II, it won the first prize in the sixth annual International Poster Biennale in Warsaw in 1976. More than marking an end to war, it reflected the exhaustion of the ongoing conflicts of the Cold War, kept hot in global clashes in Vietnam, Czechoslovakia, Nicaragua, Korea, Cuba, Angola, Iran, Greece, and Hungary. Wasilewski uses a well-known phrase from Shakespeare's *Hamlet*, but the text becomes interchangeable, or perhaps cancels itself out, forcing the viewer to take a more prominent role in its interpretation—like Hamlet, it's time to make a decision, and not simply let the world unravel around you. **S**

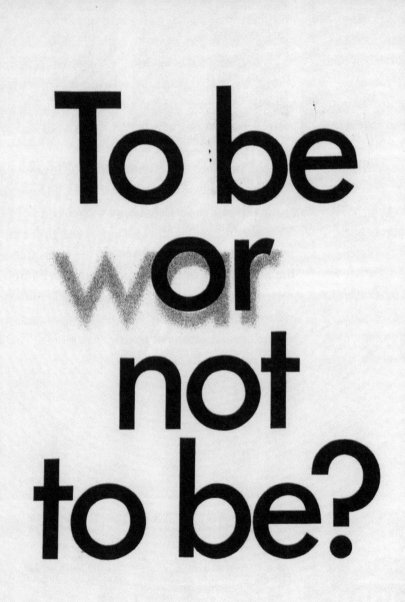

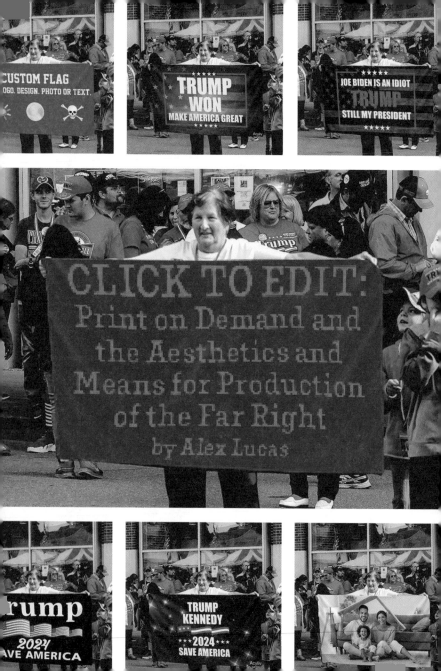

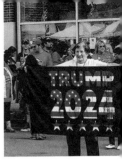

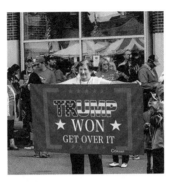

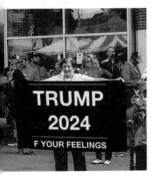

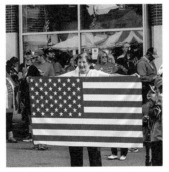

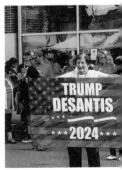

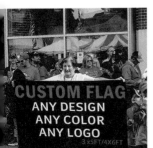

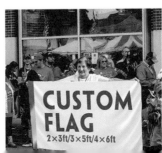

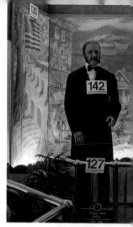

Several years ago, I visited the Hall of Presidents and First Ladies in Gettysburg, Pennsylvania, for a liquidation auction. There, wax renditions of forty-four US chief executives were available for purchase alongside the museum's brass railings, lots of office chairs, and three-quarters-size likenesses of each first lady. The auction was a mild media curiosity, and network late-night shows sent camera crews. Effigies went for anywhere from several hundred to several thousand dollars.

As the auction concluded and buyers began to pick up their winnings, an earnest wax museum aficionado from Maryland warned them to protect their presidential paraffin likenesses. "The money is in the head, the money is in the head," he anxiously repeated as auction house employees delicately decapitated each POTUS, gently removing the wax heads from their mannequin bodies for transport.

Scheduled between Election Day and Donald Trump's inauguration, the auction had a nostalgic yet jovial air. The liquidation sale felt like a recognition that the country was slowly moving past the saccharine and sanitized version of history displayed in the museum, and there was an undercurrent of relief that the then president-elect's likeness would never sully the museum's venerable halls. Still reeling from the norm-breaking ascent of Trump, the auction's timing felt like a tacit acknowledgment that we were entering a new political era.

The auction stuck in my mind over the intervening years, and as Trump's term in office came to an end, I was perversely curious to see a wax version of our forty-fifth president. One wax Trump, on view in San Antonio, Texas, was repeatedly punched by multiple visitors, necessitating its removal for repairs.[1]

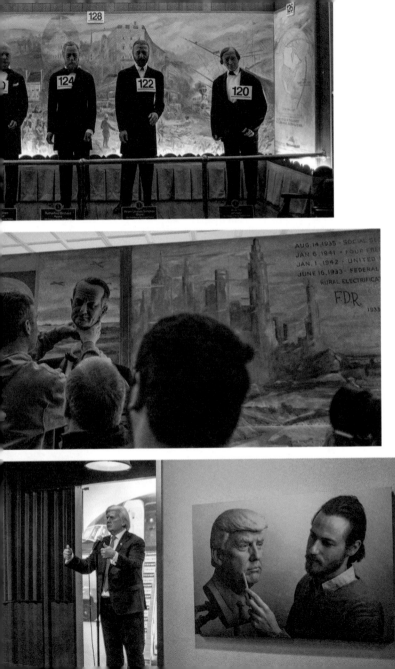

During the COVID-19 lockdown, I found a video posted on YouTube by the National Presidential Wax Museum in Keystone, South Dakota, a tourist town northwest of Mount Rushmore.[2] The video documented the team of artisans tasked with creating a wax Trump for the museum. I was especially fascinated by footage of "over fifty thousand strands of long hair [that] are carefully selected, dyed, and inserted, one by one, into the scalp using a hot needle tool." It was captivating and cathartic to watch. After the Hall of Presidents closure in Gettysburg, the video rightfully boasts that it is "the only wax museum in the world which features the likenesses of every American president."

Two weeks after my second dose of the Moderna vaccine, I hit the road and headed to Keystone to visit the museum. In retrospect, it was an ill-advised trip. Coming from Southern California, I'd forgotten how cold late spring can be, and I was surprised when it started snowing as I drove into Wyoming.

Several weeks before my visit, I called to check the museum's hours and inquire about COVID precautions. I was still wearing a mask in public, abstaining from indoor dining, and avoiding large groups, but I sensed that many South Dakotans might not share my level of caution. The previous July, amid the first COVID summer, Trump had held an Independence Day rally at Mount Rushmore.[3] News coverage of the event highlighted a lax attitude toward social distancing and face coverings. A month later, the state welcomed nearly half a million visitors for the 2020 iteration of the Sturgis Motorcycle Rally.[4] As riders returned to their homes, localized pockets of infection followed, and Sturgis was quickly labeled a super-spreader event.

Linda, who answered the phone at the museum, assured me that they were open and welcoming visitors. I asked if people wore masks while viewing the displays, and she answered, "Here, some will and some won't. It's how it is." When I called hotels in nearby Rapid City to reserve a room, I got a

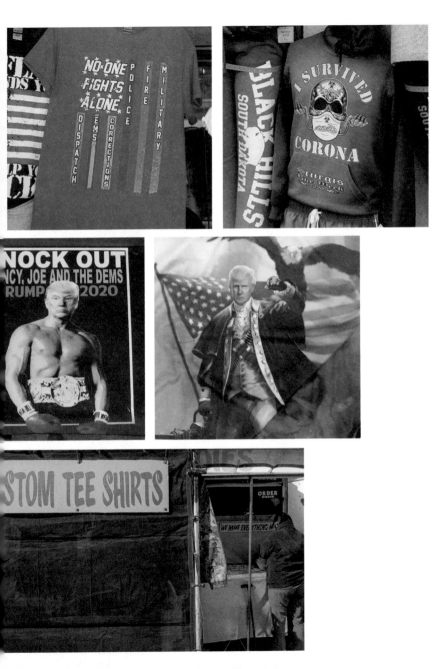

similar response. South Dakota, it seemed, was open for business.

The drive from Rapid City to Mount Rushmore takes about half an hour, and Keystone is a pinch point along the route. Traffic heading to the park entrance funnels through the town's two-lane main street, which brims with souvenir shops, ice cream stands, and family-friendly tourist activities. Keystone will seem familiar to anyone who has gone to the Grand Canyon, been to Hot Springs, Arkansas, passed through Gatlinburg, Tennessee, or visited countless other areas abutting national park entrances.

I arrived in Keystone early, and the wax museum wasn't open yet, so I wandered down the main drag's covered sidewalks. Despite the cold weather, several T-shirt shops were opening for the day. I walked into one and began to browse the merchandise. Curiously, only the first shirt was printed with a design. The rack behind was filled with a rainbow of blanks.

Sensing my confusion (and probably a potential sale), an employee approached me and explained how the store

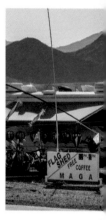

worked. Customers were invited to pick a shirt size, color, and style off the rack and pair it with one of the dizzying variety of designs displayed on the shop's walls. Any image could be printed on any shirt by simply indicating the corresponding design number stapled to the lower right corner of each sample.

In addition to designs featuring Mount Rushmore and the Black Hills, wolves howling in front of the moon, soaring eagles, and references to excessive beer consumption, a significant percentage of the imagery was overtly political:

—Design #86: Trump's head photoshopped onto a leather-jacket-clad motorcyclist flipping someone off. The text below read: IMPEACH THIS!

—Design #97: Trump's head again, smiling widely, envisioned as carved into Mount Rushmore, floating above a bullet-riddled sign for Interstate 90.

—Design #105: Trump's likeness adopting the pose of Turkish butcher Nusret Gökçe,

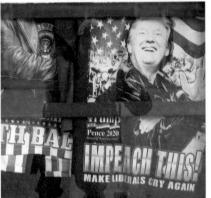

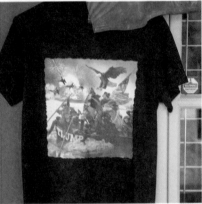

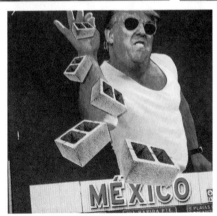

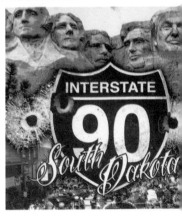

known for flamboyantly salting grilled meat under the social media handle "Salt Bae." Here, the salt has been replaced with cinder blocks, which Trump sprinkles over a highway sign pointing toward Mexico.

There were also designs declaring that blue lives matter and advocating for second amendment expansions—so many options to choose from. Incorporating a dizzying array of fonts and disparate photographic elements of varying resolutions, mashed up with inconsistent scales and perspectives, the images were a graphic design professional's nightmare.

Yet they felt familiar. At first glance, they reminded me of the paintings in which dogs play poker or shoot pool. Those works, originally painted by Cassius Marcellus Coolidge in the early 1900s, have come to define kitsch, and his images of anthropomorphized canines gathered around green felt tables, drinking whiskey and smoking cigars, are at once familiar, humorous, mildly disquieting, and synonymous with poor taste. Widely reproduced as promotional prints by Brown

& Bigelow, a company based in St. Paul, Minnesota, that specializes in the production of custom-branded merchandise and promotional items, they have also been embraced as canonical pieces of Americana. It would be a safe bet to assume that several reproductions hung within a few blocks of the T-shirt shop.

Incongruously, the designs also conjured the over-the-top look of 1990s hip-hop album covers. That blusterous aesthetic—of diamond-studded typefaces, floating Rolls-Royces, and overly abundant lens flares—was pioneered by Pen & Pixel, a Houston-based design firm founded by brothers Shawn and Aaron Brauch in 1992. Over eleven years, the Brauch brothers and their team produced more than nineteen thousand intricately designed album sleeves, primarily for rap artists based in the American South.[5] Their covers for Juvenile's *400 Degreez* (Cash Money Records, 1998) and Master P's *MP Da Last Don* (No Limit Records, also released in 1998) defined the era's look.

Invoking the aesthetics of both Coolidge and the Brauch brothers—seemingly

otherwise dissimilar moments in American visual culture—is surprisingly effective. Coolidge's most iconic work, *A Friend in Need*, from 1903, depicts two small bulldogs at a table surrounded by larger breeds. In the foreground, one bulldog slyly passes the other the ace of clubs. Here, the cheating is a mild infraction, permissible to ensure the underdog's victory (pardon the pun). This uplifting narrative transports viewers to a simpler time of smoke-filled basement rec rooms where rules are bendable and adversity is easily overcome with a little grit.

Pen & Pixel designs elicit the abundance, stability, and material comforts of the 1990s, which disproportionately benefited the white, middle-class, suburban audiences that propelled Southern rap up the mainstream charts. For many in this demographic, Master P and Juvenile's music are party anthems—golden oldies for younger Gen Xers and elder Millennials. The ostentatious displays of wealth on the album covers—initially aspirational for many of the artists, though later manifested through their commercial success—have recently found a contemporary parallel to Trump's nouveau rococo interior decoration and over-the-top gold-plated sensibilities.

The tool that allows stores like the ones in Keystone to offer such a topical variety of designs is called a direct-to-garment printer, or, colloquially, DTG. This print-on-demand (POD) technology can most easily be described as an inkjet printer designed to output on cotton. Garments are fitted over a platen that moves horizontally under the printer heads, which include white alongside cyan, magenta, yellow, and black inks. The white ink, uncommon in standard inkjet printers, provides a base layer on darker fabrics, especially for CMYK-process color designs. DTG printers were developed in the late 1990s but have gained popularity over the last ten years as prices have dropped. Available from manufacturers like Epson and Ricoh, prices for new units range from the low to mid five figures.

For shirt makers, DTG printers remove much of the overhead and labor of screen printing. There is no need for a darkroom, an exposure unit,

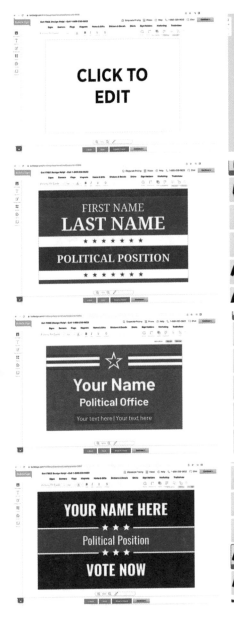

gallons of ink, or washout sinks, let alone the specialized know-how of a screen printer. Instead of outputting film positives, burning screens, mixing ink, and pulling the squeegee, with DTG one can simply click "Print" and the shirt is quickly made.

Perhaps more importantly, DTG allows for economical production without minimum print runs, dramatically reducing up-front costs. I visited several shops in Keystone where the DTG printers were on-site. One owner described how he and his staff (in this instance, his son) spend the offseason printing quantities of designs they anticipate will be popular in the coming season. This in-house manufacturing allows them to have in-demand stock on hand while remaining flexible to respond to new trends and print custom jobs. ("We print everything here," the owner explained, "except the Sturgis stuff. That's all licensed, and we need to buy it from a vendor.")

DTG technology has facilitated a new and important market: the custom-printed one-off garment. Tourists visiting Keystone can purchase custom shirts to commemorate their road trip, family reunion, or bachelorette party. The turnaround time from conceptualization through design and printing to wearing the shirt can take just minutes. While this process often produces innocuous results, it's also become an important tool for advancing political ideologies.

In one now-notorious exchange from the first debate of the 2020 presidential campaign, Fox News host Chris Wallace asked then President Trump, "Are you willing, tonight, to condemn white supremacists and militia groups and to say that they need to stand down and not add to the violence in a number of these cities as we saw in Kenosha and as we've seen in Portland?" After much prodding, Trump replied, "Proud Boys, stand back and stand by."[6]

The phrase became a rallying cry and recruiting tool for the white nationalist group. Almost immediately, T-shirts sporting the slogan in the group's

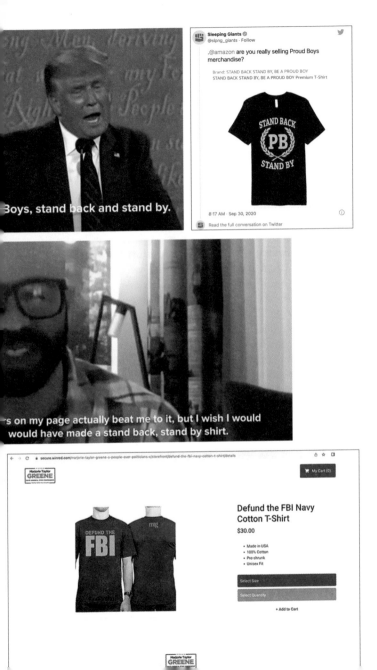

Boys, stand back and stand by.

's on my page actually beat me to it, but I wish I would
would have made a stand back, stand by shirt.

secure.winred.com/marjorie-taylor-greene-s-people-over-politicians-c/storefront/defund-the-fbi-navy-cotton-t-shirt/details

My Cart (0)

Marjorie Taylor GREENE

DEFUND THE
FBI

mtg

Defund the FBI Navy
Cotton T-Shirt

$30.00

- Made in USA
- 100% Cotton
- Pre-shrunk
- Unisex Fit

Select Size

Select Quantity

+ Add to Cart

Marjorie Taylor GREENE

signature black and yellow popped up online. The morning after the debate, Sleeping Giants (@slpng_giants), a Twitter account that describes itself as "a campaign for media, advertising, and social platform accountability," posted a screenshot of one such shirt for sale on Amazon.[7] Linda Meiseles (@Lgmeiseles) replied six minutes later, "IMO, I think this was premeditated.[8] It's too coincidental that immediately after trump [*sic*] gave a shout-out to the proud boys that the shirts went on sale." The skepticism is understandable, but Meiseles's comment belies an outdated understanding of the printing process. Historically, making a printed object takes time, even on a small scale. The image on Amazon, though, was simply a convincing digital mock-up. No ink touched the fabric, but the very illusion of print imbued the design with power and authority. It could be argued that the digital design had a farther reach and a more significant impact than any printed garment could.[9]

This online mock-up feature has become one of the most insidious aspects of print on demand. Companies like Zazzle, Vistaprint, Custom Ink, Build-a-Sign, and many others, which we can think of as online, industrial-scale versions of the shops in Keystone, allow users to quickly upload a design or input text and immediately see it on a sample product. These sites invite visitors to "Customize This Design" or "Start Designing" with a click of a button. Customers are taken to an easy-to-use interface that allows for shirt design via quick and straightforward image upload or predesigned templates or by simply starting to type. The results appear immediately on the virtual shirt and are instantaneously and endlessly updatable. Switching fonts can be done from a drop-down menu, while scaling and repositioning design elements is easily done with the mouse. The interface is more intuitive and easier to use than any Adobe product. Once designed, mocked-up images can be easily saved and uploaded to social media. Many platforms offer their own e-commerce sites, allowing users to conveniently build a web store to sell their designs. The seller never has to touch the merchandise, and there are no up-front production costs. For a

percentage of sales income, print-on-demand suppliers will produce the items one at a time as they sell, then handle payment and ship directly to the buyer.

In addition to groups like the Proud Boys, the speed and flexibility of this technology have not gone unnoticed by electoral campaigns. A web shop hosted by WinRed for People over Politicians, a political action committee for US Representative Marjorie Taylor Greene of Georgia, features many print-on-demand mock-ups, including a shirt sporting the slogan "Defund the FBI" and another dismissive of the monkeypox epidemic.[10] The merchandise looks convincing. The designs follow the contours of the model's chest and waver subtly with the drapes of the fabric. They appear to be manufactured shirts. However, several "tells" reveal a design as a digital mock-up, not a printed object: the "model" is usually white, young, fit, clean-shaven, and standing with shoulders slightly askew in a classic contrapposto pose. One hand is either tucked in or hovering just above a pocket. The image is generally cropped to include only the tip of a clean-cut, chiseled chin down to just below the waistline. The virtual model on Greene's site is identical to one advertising merch for Ron DeSantis, as well as the one used in an advertisement for a new shirt from vice-president-turned-candidate Mike Pence. The Pence shirt, released immediately after Trump was federally indicted in August 2023, reads, simply, "Too Honest."

One vendor who has taken this print-on-demand strategy to the extreme is American AF (AAF), an online store founded by Shawn Wylde, an ex-marine who served jail time for defrauding the government of close to $100,000.[11] Wylde's site offers T-shirts with slogans like "Everything Woke Turns to Sh*t" in *Tron*-esque 1980s neon and "'Merica" styled like the Metallica logo, alongside countless references to beer. An image titled "Florida Man" riffs on the *Grand Theft Auto: Vice City* cover, featuring a caricature of Ron DeSantis in a white suit. While images of the shirts sold by AAF appear to be printed, identical folds in the fabric appear across almost all the designs—a telltale sign of mock-up software.

Once customers select a design on AAF, they are taken to a

product page. Scores of designs are available as a T-shirt, a tank top, a long-sleeve tee, or a hoodie. Sizes range from extra small to 6XL, and almost all the designs can be ordered on a variety of colored fabrics. Traditionally, producing the number of variants needed to fulfill orders for a shop like this would require an enormous up-front investment for printing, shipping, and storage. Instead, at AAF, nothing is printed until an order has been received and the customer has paid. Despite an urgent countdown clock and a notice exhorting buyers to "HURRY! ONLY 8 LEFT IN STOCK" at the bottom of the page, their refunds and returns page clearly states that "We do not hold inventory or stock" and "All our shirts are made-to-order." Wylde has claimed that AAF grosses $40 million annually.[12] The selection of designs is constantly growing.

Like the Proud Boys shirt mock-ups, AAF's designs have infiltrated political discourse at surprisingly high levels. At 11:00 p.m. on Wednesday, November 27, 2019, the night before Thanksgiving, Trump tweeted an image of his head superimposed on the toned physique of Rocky Balboa without caption or attribution. While the authorship of the image remains murky, AAF claims the image as theirs. In addition to offering the *Boxer Trump* image for sale, the "Press" page links to articles about Trump's tweet from CNN, *People* magazine, and the *Guardian*.

One of the most recognizable AAF designs depicts Trump, armed, standing comfortably astride a tank emerging from the ocean on sparkling golden treads. In the background, an eagle firing a machine gun swoops between fireworks and explosions. This is the artwork of Jason Heuser, whose Instagram profile (@president_heuser) describes him as the creative director at AAF and the "most known unknown artist." Other works by Heuser imagine an armed Abraham Lincoln riding a bear, Teddy Roosevelt as a contemporary military sniper, and George Washington performing a "stunner" wrestling move on a bleeding redcoat soldier. It is as if Heuser

is channeling Pen & Pixel's Shawn Brauch, who described their design ethos as "the more outlandish, the better."[13] Several of Heuser's works, including *D Treezy* and *Flair Trump*, feature photoshopped piles of cash, lens flares, and shiny lettering, explicitly referencing Pen & Pixel designs. It feels at once evocative of the Nineties, appropriative of an aesthetic initially used to promote Black artists, edgelordy, and decidedly on-brand for AAF.

One indicator of the reach of Heuser's work is its presence at the January 6 insurrection. Like Cassius Marcellus Coolidge, Heuser's works have been widely duplicated, frequently as flags. In his first-person account of that day, journalist Luke Mogelson describes arriving at the Ellipse in Washington, DC, around 8:00 a.m.: "The first thing that caught my attention was the flags."[14] Viewing photos of the insurrection, the sheer number and variety of banners flown that day is astounding. In addition to historical designs, like the Confederate Stars and Bars and the Gadsden "Don't Tread on Me" flag, there were any number of variants of "Trump 2020" in

blue and white, Q-Anon banners, (ironically) Blue Lives Matter flags, and American flags superimposed with various text and symbols. The print quality of the banners appeared high—these were not homemade signs. Hauser's *Trump Tank* appeared repeatedly in the fray.

While flags have long been ways to signify membership, allegiances, and sympathies, their prevalence has increased over the past two presidential campaign cycles. New print technology has enabled this expansion. Like T-shirt printing, it's now possible to cheaply procure custom-designed, one-of-a-kind flags using a technique called dye sublimation printing. A close cousin to the direct-to-garment printers in Keystone, "dye-sub" allows intricate CMYK images to be printed onto fabric through a thermal transfer process. First, the design is printed onto transfer paper using an inkjet printer outfitted with specialized heat-activated inks. The paper is then inserted in a

CUSTOM FLAG
Your
Photo/Text
Here

,200+RATINGS
STOM FLAG
PICTURE/TEXT/LOGO
3 FT/3X5 FT/3X6 FT
E SIDED/DOUBLE SIDED

CUSTOM
FLAG
2×3/3×5/4×6/5×8 FT
Double Sided/Double Sided

M

EXT
FT

CUSTOM Flag
3×2/5×3/6×4/5×8 FT
LOGO/TEXT/PHOTO
Many background colors are acalable

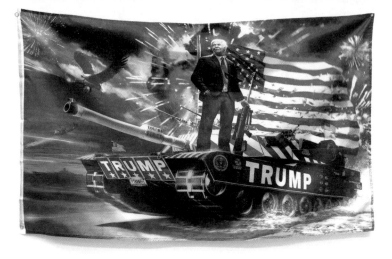

heat press sandwiched with the final substrate, often a specially treated polyester. When exposed to high temperature, the ink turns into a gas and transfers to the fabric.

Like DTG printing, the process takes only a few minutes and caters to full-color designs. Flag production no longer relies on stitched fabric, embroidery, or screen printing. Importantly, this type of printing is perfectly suited to the digitally produced designs that circulate online, such as *Boxer Trump* or *Trump Tank*. Like DTG, dye-sub printing can bring memes and meme-like imagery offline and into the away-from-keyboard world, creating fast and affordable one-off output of full-color designs.

A quick search on Amazon yields thousands of vendors offering custom flags for sale. For under twenty dollars, including shipping, a three-feet-by-five-feet flag can be ordered and shipped to your door. Listings typically feature a single flag reading "Your Text/Image/Logo Here." Though it appears innocuous, digging into the postings frequently reveals a thinly codified design sensibility intended to appeal to the American right. One Amazon posting features an image of six flags on a white background. Two are inscribed with variants on Trump's "Make America Great Again" campaign slogan. Another posting features a flag sporting a vanilla affirmation: "You're Braver than You Believe, Stronger than You

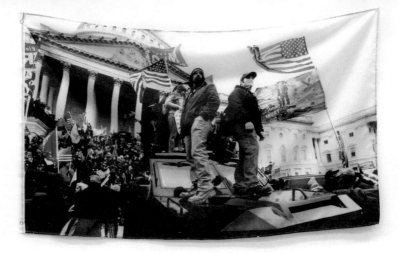

Seem, and Smarter than You Think." The text, white on a blue background, surrounded by a red square with four stars above and below, closely mirrors the design of Trump's campaign yard signs. The primary image for a third listing depicts the stars and stripes with Trump's distinct profile superimposed on the right behind the text "CUSTOM FLAG."

One image seen across many Amazon postings features a smiling middle-aged woman in a white T-shirt and brown slacks holding a flag between her outstretched arms. In various listings, her flag has been altered to feature two dolphins jumping across a sunset, a couple playing with their young child in front of a mid-century modern couch, an antivax message, and "TRUMP 2024" superimposed over the American flag. There is a crowd behind the figure, several outfitted in Trump shirts and hats. Across variants, these background figures remain unaltered. Our protagonist is always at a Trump rally.

The original photo was taken by Rosemary Ketchum in late September 2018 as a crowd waited to enter a Trump rally in Wheeling, West Virginia. At the event, the then president sought support for his second Supreme Court nominee, Brett Kavanaugh. In the unaltered version of the photo, posted as "free to use" on the website Pexels.com, her flag is semitranslucent and reads: "Trump, Keep America Great Again, 2020."[15] The widespread appropriation of this photo is telling—it reveals an understanding that the context for these custom-printed

flags has largely been in support of right-wing ideologies. From front porches to so-called Trump Trains to participants in the violence of January 6, these flags have become mainstays of early twenty-first-century right-wing political action in America.

While writing this article, I bought four shirts from the American AF web store and ordered several flags on Amazon. The two Trump flags I ordered, versions of Heuser's *Trump Tank* and *Rambo Trump*, arrived within a few days from warehouses in Riverside County, California, and suburban Cincinnati. The resolution on both flags was low, and the colors were washed out. It looked like the images had been saved from the web. The polyester fabric and lighter reverse side were clear hallmarks of dye-sub production, though the speed of delivery made me think these had been preprinted en masse.

The interface for ordering custom flags was straightforward to navigate. First, I picked a background color. One vendor offered black, white, or red, while another posting provided a drop-down menu

of background options that included solid colors, multiple versions of the American flag, Pride flags, a Juneteenth flag, and a Blue Lives Matter flag. Like other online print-on-demand services, text could be superimposed in various fonts over any of these backgrounds by simply typing into a TEXT INPUT field. The character maximum was two hundred, just shorter than the length of a tweet. There was also an option to upload an image from your desktop.

As an experiment, I uploaded three photographs of the January 6 insurrection. In each image, the type of right-wing printed ephemera discussed in this article can be seen in the fray. The source files, all found on the websites of mainstream news publications, were roughly 1,500 to 2,000 pixels wide—sizable for web-based images but low resolution for printing. Two of the files uploaded without a problem. I was able to resize and reposition the photos on the digital mock-up before submitting the order, and there was no question about the content or copyright of the photographs. A third image, capturing fifty-three-year-old

Kevin Seefried parading through the Capitol, wouldn't upload. After trying, unsuccessfully, to submit it through several different vendors, I gave up and abandoned that photo. I remain unsure if there was a problem with the source file's formatting, a copyright issue, or a block triggered by the Confederate battle flag in Seefried's hand.

Shipping notifications for the custom flags popped up in my inbox within a few days. The tracking numbers all originated from China. When the packages arrived about two weeks later, I was surprised by the quality. Each had been hemmed after printing and affixed with sturdy brass grommets. They were, overall, surprisingly high-quality objects.

Procuring shirts from American AF was a more frustrating experience. A banner at the top of their home page announced, "Buy Three, Get One Free," but the discount code didn't work at checkout. After contacting customer support, I was informed that the promotion didn't apply to Trump merchandise. AAF's email response came from "Captain America," who, as a consolation, provided a discount code for 15 percent off. While this felt like a bait and switch, I proceeded with my order of four shirts.

After three weeks of waiting for a shipping confirmation, I emailed customer support again. The AAF website indicated that production usually took "3–7 days," but the Captain explained that the Trump shirts are one of their "special items [which] usually take 3–4 weeks to make." While I waited, the former president's indictment count continued to rise, as did his poll numbers. I presumed there could be a parallel resurgence in the demand for merch, and AAF might be stretched thin.

Five weeks after I placed my order, the shirts arrived in patriotic packaging. The colors of the shirts were bright, and the resolution was sharp. Unlike the flag version of *Trump Train* I'd ordered on Amazon, I could discern the fine detail in Heuser's design—the faces of political rivals crossed out with a red *T* on the tank's side and the golden flags on the tank treads. The printed product looked almost identical to the online digital mock-up. An elaborate embroidered tag featuring a screaming eagle was sewn into the neckline. Like the custom-printed flags, the shirts were well crafted. I was impressed.

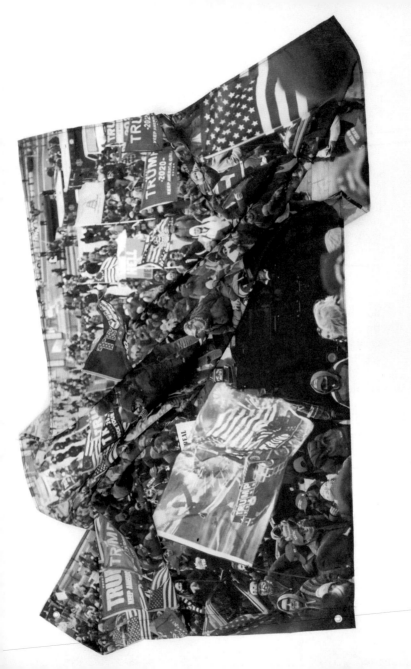

But I don't know what I'll do with any of the items I bought. The polyester dye-sub fabric substrate is slick, and the shirts feel dense. Apart from the political connotations, I can't imagine wearing one of the shirts would be very comfortable. Unlike the screen-printed heavyweight cotton tees handed out by union organizers and given to volunteers at political rallies, these shirts will not feel any better after a few washes. These objects are not intended to age well. They do not need to. The political power of POD technology does not lie in the materiality of its output. Rather, its strength lies in its immediacy, accessibility, and updateability. It is a medium built for speed.

I remember during the run-up to the 2016 election, "This Machine Kills Fascists" stickers were affixed to Risographs, laser printers, and relief presses across the country, and signs featuring the phrase were posted in the windows of cooperative and academic print shops alike. Print, this repurposing of Woody Guthrie's famous slogan supposed, would save democracy. But those analog traditions of printmaking, historically employed with great effect by leftists, progressives, anarchists, and labor movements, risk being outpaced by POD. Moreover, the embrace of this new technology by the right has largely codified a set of aesthetics as associated with political movements that range from conservative to proto-fascist. The professional appearance of POD prints, coupled with an antiquated understanding by the public at large of how prints are made, lends the technology an air of officialdom. A one-off flag easily masquerades as one of many. A digital mock-up of a T-shirt imbues the design with a sense of being part of a large movement. Simultaneously, the endless possibilities for customization appeal to a sense of rugged individualism prized by the right. The prints themselves are secondary.

On August 24, 2023, I watched news coverage of Trump emerging from his motorcade to address the press. He'd just been arrested in Fulton County, Georgia, for attempting to interfere with the 2020 election. As in the Keystone display, Trump stood in front of his iconic jumbo jet, speaking to the gathered crowd, though any hint of a smirk was absent.

Trump's mug shot was released by the Fulton County Sheriff's Office shortly after Trump Force One departed. Within an hour,

Donald Trump Jr. tweeted, "Free Trump Merch! To be clear, all profits from this on my Web Store are going to be donated to the Legal Defense Fund to fight the tyranny & insanity we're seeing before us. Unlike many, I won't try to profit from this but will do what I can to help," followed by a link to ShopDonJr.com.[16] The website features five T-shirts and four hoodies alongside flags, posters, bumper stickers, and innumerable beer koozies, all sporting the now-infamous photo. Within a week, this imagery helped raise millions of dollars for Trump.

The wax version of Trump in Keystone's National Presidential Wax Museum stands in front of his branded Boeing 757 with both hands clenched in a double thumbs-up salute. One corner of his mouth is slightly upturned, the slightest glimmer of a smirk on his otherwise stern face. Unlike the other presidential likenesses in this museum, Trump is not engaged in statecraft or diplomacy. He is not positioned in the Oval Office, attending to a national crisis or meeting with foreign dignitaries. Instead, Trump's wax figure faces a wall-sized photograph of an arena-sized crowd filled with Make America Great Again signs. The forty-fifth president is not commemorated in a moment of governance but frozen in a perpetual campaign. There isn't much to be nostalgic for here. One placard in the crowd is blurred out, presumably too vulgar for the museum. **S**

All images courtesy of the author.

NOTES

1 Jesus Jiménez, "After Being Scratched and Punched, Trump Wax Figure Is Removed," *New York Times*, March 20, 2021, https://www.nytimes.com/2021/03/20/us/trump-wax-museum.html.

2 The National Presidential Wax Museum, "Welcome to the National Presidential Wax Museum— Keystone, South Dakota," YouTube, March 9, 2018, video, 6:17, https://www.youtube.com/watch?v=WbzaFBNlEoY.

3 As reported deaths from COVID-19 in the United States neared 130,000 and the daily rate of infection passed 50,000, President Donald J. Trump held an Independence Day rally at Mount Rushmore. His remarks barely mentioned the virus, instead focusing on an emergent "new far-left fascism" whose proponents were "determined to tear down every statue, symbol, and memory of our national heritage." The White House, "Remarks by President Trump at South Dakota's 2020 Mount Rushmore Fireworks Celebration, Keystone, South Dakota," news release, July 4, 2020, https://trumpwhitehouse.archives.gov/briefings-statements/remarks-president-trump-south-dakotas-2020-mount-rushmore-fireworks-celebration-keystone-south-dakota.

4 An event later labeled by the CDC as the site for significant spread of COVID-19. Melanie J. Firestone et al., "Center for Disease Control Morbidity and Mortality Weekly Report: COVID-19 Outbreak Associated with a 10-Day Motorcycle Rally in a Neighboring State—Minnesota, August–September 2020," Centers for Disease Control and Prevention, November 27, 2020, https://www.cdc.gov/mmwr/volumes/69/wr/mm6947e1.htm.

5 Matt Schoen, "Defining the Visual Style of Southern Hip Hop," Noisey Design, Vice Media, October 6, 2014, video, 11:51, https://web.archive.org/web/20141010083525/http://www.youtube.com/watch?v=08rPLhdBpQI.

6 The Commission on Presidential Debates, "Presidential Debate at Case Western Reserve University and Cleveland Clinic in Cleveland, Ohio," transcript, September 29, 2020, https://www.debates.org/voter-education/debate-transcripts/september-29-2020-debate-transcript.

7 Sleeping Giants (@slpng_giants), "@amazon are you really selling Proud Boys merchandise?," X (formerly Twitter), September 30, 2020, 10:17 a.m., https://twitter.com/slpng_giants/status/1311324228004634629.

8 Linda Meiseles (@Lgmeiseles), "IMO, I think this was premeditated. It's too coincidental that immediately after trump gave a shout out to the proud boys that the shirts went on sale," X (formerly Twitter), September 30, 2020, 10:23 a.m., https://twitter.com/Lgmeiseles/status/1311325849317249026.

9 During the investigation into the January 6 attack by a House select committee, Senior Counsel Candyce Phoenix asked Proud Boys leader Enrique Tarrio, "Did you ever sell any 'Stand Back and Stand By' merchandise?" Tarrio replied, "Uh, one of the vendors on my page actually beat me to it, but I wish I would have—I wish I would have made a 'Stand Back, Stand By' shirt." NPR, "Here's Every Word of the First Jan. 6 Committee Hearing on Its Investigation," transcript, June 10, 2022, https://www.npr.org/2022/06/10/1104156949/jan-6-committee-hearing-transcript.

10 "Made in America Merch," on Marjorie Taylor Greene's People over Politicians website, accessed October 18, 2023, https://secure.winred.com/marjorie-taylor-greene-s-people-over-politicians-c/storefront.

11 Dave Philipps, "With Their Leaders at a Loss, Marine Veterans Fight Abusers," *New York Times*, March 17, 2017, https://www.nytimes.com/2017/03/17/us/with-their-leaders-at-a-loss-marine-veterans-fight-abusers.html.

12 Elizabeth Lawrence, "Marine Veteran Shawn Wylde Just Won't Quit as He Looks to the Future," *American Military News*, September 17, 2020, https://americanmilitarynews.com/2020/09/marine-veteran-shawn-wylde-just-wont-quit-as-he-looks-to-the-future.

13 Schoen, "Defining the Visual Style of Southern Hip Hop."

14 Luke Mogelson, *The Storm Is Here: An American Crucible* (New York: Penguin Press, 2022), 228.

15 Rosemary Ketchum, "Woman Holding Trump Keep America Great Again 2020 Banner," Pexels photo, September 29, 2018, https://www.pexels.com/photo/woman-holding-trump-keep-america-great-again-2020-banner-1464210.

16 Donald Trump Jr. (@DonaldJTrumpJr), "Free Trump Merch! To be clear all profits from this on my Web Store are going to be donated to the Legal Defense Fund to fight the tyranny & insanity we're seeing before us," X (formerly Twitter), August 24, 2023, 9:02 p.m., https://twitter.com/DonaldJTrumpJr/status/1694892935077040387.

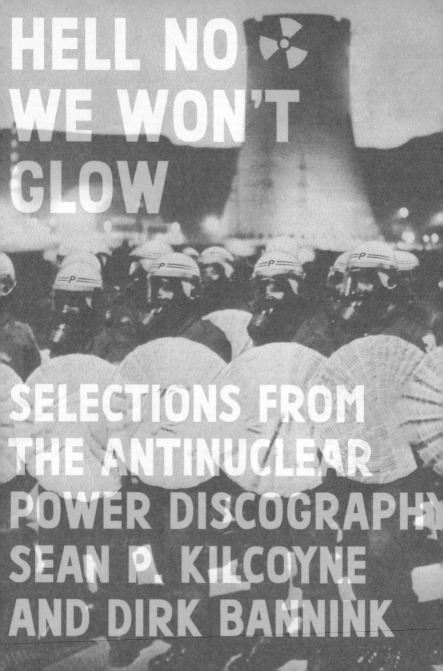

HELL NO
WE WON'T
GLOW

SELECTIONS FROM
THE ANTINUCLEAR
POWER DISCOGRAPHY
SEAN P. KILCOYNE
AND DIRK BANNINK

nitially sold to the public as an energy source "too cheap to meter," nuclear power has instead relied on taxpayer bailouts and billion-dollar subsidies to operate competitively. Presented as a safe and clean technology, nuclear energy has been responsible for scores of serious radiological accidents, poisoning ecosystems and nearby communities. And now, with humanity facing multiple converging, existential crises, the same powers that brought us here are promoting nuclear energy as our best hope for survival. Unfortunately, even some on the radical left have embraced this position, failing to engage with the reality that nuclear energy is a water-intensive technology that is not viable in a collapsing climate, nor is it quickly scalable, or even carbon-free. Nuclear power's many harms are not evenly distributed across society, as women, children, poor people, disabled and chronically ill individuals, Indigenous populations, and other communities of color have suffered its multi-tiered impacts disproportionately. Whatever positive reputation the technology has enjoyed at differing stages in its history is entirely unjustified. As *Peace News Pamphlet*'s 1982 *Anti-nuclear Songbook* says, "The nuclear chain is a long series of horrors from the destruction of aboriginal lands by uranium mining, right through to ballistic missiles, power stations, and radioactive waste dumping. We must stop it all." Here we present a carefully abridged selection of international antinuclear music focusing on an idiosyncratic body of artists, records, and songs protesting the so-called peaceful atom.

While this article strives to achieve a truly international scope, recordings originating in Europe and the United States are discussed

more extensively. There are many reasons for this emphasis. First and foremost, the origins of this article are rooted in a project that documented music written in response to the Three Mile Island accident in 1979. A second author was recruited for his expertise in various European antinuclear struggles. Nevertheless, even in this age of machine translation, language barriers have worked against us. We also assume a great deal of music has gone unrecorded or has been haphazardly distributed. Aside from these limitations, there is simply far too much to discuss, so we go into detail about Three Mile Island, for instance, at the expense of Windscale, Chernobyl, or Fukushima. We do not intend this article to be definitive; rather, it is an effort to engage with some of the historical legacies of the antinuclear power movement as seen through its music.

One final aside before we jump in: the women's organized protests at the Greenham Common military base in the UK is one of the most well-known protests against nuclear weapons, especially in the English-speaking world. Even though they are the paradigmatic example of feminist struggle against the nuclear regime, because this article is largely focused on nuclear power, not weapons, we will not get deeply into Greenham Common or the music the protests generated. (This also deserves an entire article of its own!)

UNITED STATES: THE BATTLE FOR BODEGA BAY (1958-64)

On November 1, 1952, the United States detonated the world's first thermonuclear weapon, vaporizing much of the Enewetak atoll with an explosion one thousand times more powerful than that of Hiroshima. Thirteen months later, President Dwight D. Eisenhower stood before the United Nations making his "Atoms for Peace" speech, urging the world to "move out of the dark chamber of horrors and into the light" by embracing another side of the atom, one that allegedly offered an inexhaustible solution to the world's energy needs. The underlying logic suggested that by adopting nuclear power, the threat of nuclear war was somehow magically reduced. Regular atmospheric nuclear tests of nuclear weapons by the military

superpowers suggested otherwise. Soon, large-scale, organized anti-nuclear weapons protests began to develop in Japan, the United Kingdom, West Germany, and elsewhere. Initially, there was not a corresponding outcry against nuclear power. The propaganda on behalf of nuclear power was relentless, and people desperately wanted to believe there was more to be gained from nuclear fission than the threat of human extinction.

In the United States, the first commercial generating re-actor did not go online until late 1957, when the experimental Shippingport Atomic Power Station began transmitting electricity to nearby Pittsburgh, Pennsylvania. The following year, the Sierra Club got an anonymous tip that Pacific Gas and Electric (PG&E) was planning to build an "Atomic Park" on Northern California's coastal Bodega Head. Many in the conservation movement retained an open mind about nuclear energy, finding it preferable to the known harms of coal or hydropower. PG&E's promotional materials depicted a pristine, futuristic facility exquisitely balanced with the natural world. The Sierra Club's old guard was passionate about wil-derness preservation but wished to preserve collegial relationships with various civic power brokers. When the club ultimately objected to PG&E's Atomic Park, they made it clear that it was for aesthetic reasons, not ideological or environmental ones. The more militant club members, led by David Pesonen, had no interest in appeasing a utility that conspired behind the public's back with local politicians. With Pesonen acting as executive secretary of the ad hoc Northern California Association to Preserve Bodega Head and Harbor, ac-tivists fought PG&E on several fronts. Since the plant was just a

stone's throw from the San Andreas Fault, seismology proved the most obvious and effective intervention.

Music played a crucial role in the struggle. On Memorial Day 1963, 1,500 helium balloons were released at a concert on Bodega Head, each one with the message that PG&E was building a reactor and that the balloon could just as well be a harmful molecule of strontium-90 or iodine-131. Most of the musicians present, including Malvina Reynolds, Turk Murphy, Lu Watters, Barbara Dane, and the Goodtime Washboard Three, played a second concert for the association later that summer at the San Francisco club Earthquake McGoon's. Several of the musicians also immortalized the fight with newly written songs. Malvina Reynolds, whose "Power Plant Reggae" became one of the definitive late 1970s antinuclear songs, contributed "Take It": "They're starting a plant at Bodega / A place that was wild and pure / They call it an atomic park / But it's an atomic sewer." The Goodtime Washboard Three, who described themselves on the reverse side of their LP as "part Jazz of the New Orleans–San Francisco variety; part folk . . . and part vaudeville," wrote "Don't Blame PG&E, Pal," a satire adopting the perspective of a cynical utility executive. It was also released as a single. The song is rich in wordplay and employs their versatile washboard to produce a humorous cacophony of horns, bells, whistles, and bird chirps, all of which terminate in a tremendous explosion. Jazz musician Lu Watters, who came out of retirement to "blow down an atomic power plant," is joined by future Paredon Records founder and vocalist Barbara Dane on the title track of his 1964 LP *Blues over Bodega*. Watters wrote a few other originals, but only the instrumental opener, "San Andreas Fault," is topical to Bodega. Pesonen's antiatom liner notes on the record sleeve add context and heft to the record while declaiming, "Jazz is a vote of no confidence in the Establishment." Happily, the Establishment, as represented by the Atomic Energy Commission, concluded that they, too, had no confidence in PG&E and their Atomic Park should an earthquake shake the San Andreas. The plan was canceled in 1964.

SEABROOK (1969-89)

In 1969, the Public Service Company (PSC) of New Hampshire announced plans to construct two reactors along the coast in Seabrook, forty miles north of Boston. Despite litigation from the Seacoast Anti-pollution League and widespread citizen opposition, the PSC was granted permission to begin construction in the summer of 1976. The Clamshell Alliance formed in response, organizing their first direct action on August 1, 1976. The Clamshell Alliance took inspiration from the successful antinuclear resistance at West Germany's Wyhl. Furthermore, Clamshell Alliance literature cited the influence of the Federación Anarquista Ibérica (Iberian Anarchist Federation), whose decentralized organizing and affinity group structure helped them liberate vast amounts of territory in 1920s and 1930s Spain. "The Clam," in turn, was quite influential on both the American and international antireactor movements. Feminism was particularly integral to the Clamshell Alliance's ideology and organizing principles. Affinity groups were generally ten to twenty individuals who undertook mandatory nonviolence training

OCCUPY SEABROOK
OCT.
6th
1979
Call 617-661-6204
WE Will Stop Nuclear Power

together. Individual "Clams" were encouraged to form groups with friends, classmates, and people from their own community. This allowed the organization to grow numerically while improving its resilience against infiltration. Every cell had a spokesperson, or "spoke," democratically chosen by the affinity group to represent it in communications with the larger Decision-Making Body. Each group also had a medic capable of administering first aid, a support person to address logistics on the outside while the affinity group engaged in direct action, and somebody who could deal with provocateurs, should any be identified.

The initial direct actions in August 1976 resulted in double- and triple-digit arrests. An even larger April 1977 site occupation resulted in over 1,400 arrests, with hundreds of activists jailed for weeks, refusing to post bail. The following summer saw a preapproved and legal "Restoration—Rally—March" with over twenty thousand demonstrators in attendance, many camping on PSC property from June 24 to 26. This can be viewed as the peak of the Clamshell Alliance, with conflicts over tactics soon overtaking the momentum of the organization. Sporadic actions persisted for several years and reignited in the late 1980s, post-Chernobyl, as the plant neared completion. Although Seabrook Station eventually opened in 1990, the second of two planned reactors was canceled, and PSC had to file for bankruptcy.

PAT & TEX
DeCou LaMountain

Down Here on the Earth

Opposite: "Occupy Seabrook" flyer, 1979. Above: Pat DeCou & Tex LaMountain, *Down Here on the Earth* LP, Rainbow Snake Music, 1979.

Throughout all this, participants in the struggle were writing, singing, and, in a few cases, recording music. Pat DeCou and Tex LaMountain brought their antinuclear music to the first direct actions, inspiring others. In 1977, DeCou and LaMountain released a two-song 45 in a textured gatefold cover emblazoned with a three-colored snake design on the front and pictures of the previous year's demonstrations within. Anna Gyorgy, principal author of the book *No Nukes: Everyone's Guide to Nuclear Power*, contributed liner notes. The A-side, "No Nukes (Hanging Tree)" was inspired by Sam Lovejoy, a Massachusetts organic farmer who, three years before, sabotaged a weather tower at a proposed nuclear plant in Montague, Massachusetts. The flip side, "Karen Silkwood," tells the story of

the former Kerr-McGee plutonium processing plant worker turned whistleblower who became a movement martyr after her suspicious death in 1974. The insert argued for a grassroots movement to demand answers to the questions addressed in the song and furnished contact information for the recently formed Supporters of Silkwood. DeCou and LaMountain's other recorded antinuke track, "Seabrook Song," turned up on their 1979 album, but it had already appeared a year earlier on the soundtrack of *Seabrook 1977*, a documentary film made about the occupation.

The musician Charlie King, along with Joanna McGloin, Rick Gaumer, and Joanne Sheehan, founded Songs for Freedom and Struggle (SFS) to establish community between politically minded musicians. As the organization matured over the next few years, it evolved into the People's Music Network, and it remains operational

to the present day. Back in 1977, some musicians from the newly formed SFS converged on Seabrook. Around this time, King wrote "Acres of Clams," adapting the folk standard "The Settler's Song" to create one of the American antinuclear movement's most well-known tunes: "I've lived all my life in this country / I've loved every flower and tree / I expect to live here till I'm ninety / It's the nukes that must go and not me." Pete Seeger adapted the song as a show of solidarity with Clams jailed for civil disobedience. Charlie King was among the activists arrested at various Seabrook occupations, something he described in his 1977 song "No Place Like Jail for the Holidays."

Songs were not only written about jail, but also in jail, where they were also performed to pass the hours. The Crumbs of Bliss, an affinity group from Dekalb, Illinois, formed by Movement for a New Society seminar activists, packed into several old cars and drove

to Seabrook, where they were eventually imprisoned with 1,400 other demonstrators. While jailed, the Crumbs of Bliss remained more or less intact and performed their recently written antinuclear theater piece in confinement. They also introduced their music to the New England activists, including "Nuclear Power Blues," written by Dekalb songwriter Dave Williams and issued on 45 around this time. Crumbs of Bliss member Court Dorsey would team up with Charlie King, Pat DeCou and Tex LaMountain, and several other musicians—Cheryl Fox, George Fulginiti-Shakar, Ken Giles, and Marcia Taylor—to form the traveling act Bright Morning Star. Bright Morning Star took their name from an Appalachian hymn that members reworked while being shuttled between the National Guard armory and trial. The song recounts their struggle against Seabrook and appears on the band's first LP. Similarly, Pat Scanlon, an organizer with the Merrimack Valley Clamshell Alliance and Veterans for Peace, wrote a batch of Seabrook songs that were performed at antinuclear rallies in the late 1970s. "Marching up to Seabrook" and "Standing Here Together" turned up on Scanlon's 1984 debut LP, *Songs for Future Generations*, a benefit for Greenpeace New England. The front cover shows Scanlon and the Blackwater String Band posed before the Seabrook site, while the back cover has an array of children under a rainbow Greenpeace banner that demands "Freeze the Arms Race Now." The songs reflect a concern with nuclear war, nuclear power, ecology, peace, and sustainability.

The lyrics and chords to much of the above music appeared in the 1978 pocket-sized publication *Songs to Stop Seabrook*. Characteristic of the exchanges occurring between politicized folk musicians at this time, songs originating from other antireactor battles, including the

Diablo Canyon Power Plant in California and the Satsop Nuclear Power Plant in Washington, appeared in the songbook. It is worth noting that sharing music is a typical feature of folk music, as is the tendency for musicians to add a verse of their own to an established song. In other cases, songs are written and then shelved for years until circumstances make them relevant again. This has happened time and again with antinuclear music, which has often found its largest audience in the immediate aftermath of one radiological disaster or another. Brownie MacIntosh's "Seabrook Is Glowing in the Dark," based on an idea by Frank Kelley and Joe Daly, was written in the late 1970s and debuted locally to great fanfare. It did not see release until 1986, when it turned up as the opening track on a live LP documenting an American Folk Theater hootenanny. As MacIntosh explains in the preface to the song, he only chose to perform it that night because Chernobyl had exploded, bringing nuclear power and Seabrook back into public view.

BLACK FOX (1973-82)

The year 1973 was the high-water mark of America's romance with nuclear power, measured in terms of thirty-five new reactor orders, the highest annual total before or since. In May 1973, Public Service Company of Oklahoma (PSO) announced its intention to build two reactors outside of Inola, a rural community near Tulsa. Because of citizen pushback encountered at Bodega Bay, Ravenswood, Malibu, and elsewhere, utilities like PSO believed their odds of building reactors quickly, and therefore cheaply, would be improved if they could bribe working-class and poor communities with jobs and tax revenue. Despite these calculations, PSO faced tenacious resistance from Carrie Barefoot Dickerson, a local grandmother and nursing home operator. Known to friends as "Aunt Carrie," Dickerson educated herself on nuclear power and challenged PSO on a variety of legal grounds: the potential pollution of the local drinking water supply, the absence of plans to address nuclear waste, and the inevitable rate hikes that starkly contradicted the promise of an energy

supply "too cheap to meter." Inspired by Ralph Nader, Dickerson formed the Citizens' Action Group, which became Citizens' Action for Safe Energy (CASE).

Dickerson's legal interventions slowed down the licensing process and revealed important safety oversights but drained her resources, forcing her to sell the nursing home and mortgage her stake in her family's farm. It seemed unlikely Dickerson would prevail, given how impossibly the deck was stacked in the utility's favor. Nevertheless, by delaying PSO's efforts to get a construction license, Aunt Carrie and CASE made it possible for allies to join the fight. Upstart groups, including Citizens Against Black Fox (CABF) and the student-formed Citizens Against Radioactive Exposure (CARE), organized with CASE under the name the Sunbelt Alliance. This new group also included unaffiliated artists, musicians, and Indigenous groups. The alliance worked momentarily, but it began to splinter as some of the older, more moderate activists led by Aunt Carrie favored legal intervention while the younger university students and radicals took inspiration from the direct action approach of the Clamshell Alliance. These differences led CASE and CABF to withdraw from the Sunbelt Alliance shortly after joining, although cooperation between all anti–Black Fox protagonists continued until the end of the campaign.

The compilation record *For Our Children: Black Fox Blues?* captures the musical side of the anti–Black Fox movement in 1978, shortly after the Sunbelt Alliance coalesced. Benefiting both CASE and the Sunbelt Alliance, the record was dedicated to, among others, Aunt Carrie, "street legal and early warning system, grandmother to us all." Dickerson's autobiography, *Aunt Carrie's War against Black Fox Nuclear Power Plant*, does not mention the LP but does discuss MUSE (Musicians United for Safe Energy) concerts, where local artists such as Marilyn Oldefest and Randy Crouch performed on benefit bills with Jackson Browne, Bonnie Raitt, and David Lindsay. Both Oldefest and Crouch have tracks on *For Our Children: Black Fox Blues?* Oldefest's song, "Black Fox," is a plea to evaluate nuclear power's risk to human health against the relatively trivial needs symbolized

FOr our cHildren

BLACK FOX BLUES ?

HALFWAY TO CHINA
and Armchair Activist by
M.A.S.S.
MUSICIANS ALLIED TO STOP SHOREHAM

Nuclear power plants across our country pose a
potential threat to the health and safety of our
families and friends, and can destroy the
economic stability of our communities. This
record is the result of a community effort by
individuals who are dedicated to actively
oppose the operation of LILCO'S Shoreham
Nuclear Power Plant on Long Island.

This purchase of this record will help that cause. Together, we can make the difference.

ALL PROFITS FROM THE SALE OF THIS RECORD GO TO
LI/USA - Long Islanders United for Shoreham Abandonment
a non-profit organization

LOUISIANA RED AntiNuclear Blues

by the electric toothbrush. It is typical of the earnest, issue-oriented approach to songs found on the compilation. Crouch, on the other hand, provides the album's stylistic outlier, "Radiation," a slice of odd-ball funk with electric fiddle, keyboards, horns, and assorted sound effects. All this makes perfect sense when paired with the lyrics: "All across the nation / New York to San Francisco / There's people doing the mutation / Down at the atomic-powered disco." Crouch describes his body of material as "Oklahoma Protest Music," and both this and his other contribution to the compilation, "Sun & Wind," assert his unique vision. The remaining songs address nuclear power in one way or another, except for "As Long as the Grass Shall Grow," Hal Rankin's cover of a Peter La Farge song previously popularized by Johnny Cash. While not about nuclear power, this is a choice worth remarking on because it connects energy generation to a wider pattern of injustice, displacement, and colonialism. When La Farge composed the song in the early 1960s, the US government was planning to build a massive hydroelectric dam that would flood ten thousand acres of the Seneca Nation, violating their sovereignty and displacing approximately six hundred people. Unfortunately, this came to pass shortly after the song was written, despite the existence of viable alternatives.

Fourteen Sunbelt Alliance activists were arrested on Halloween night 1978 after trespassing onto the Black Fox site and chaining themselves to construction equipment. On June 2, 1979, as the anti-nuclear movement surged in the aftermath of the Three Mile Island accident, another five hundred activists engaged in a subsequent Black Fox occupation. Despite this, things were still looking positive for the utility until they asked for a 40 percent rate increase, vindicating Aunt Carrie's theory that greed would prove their Achilles heel in fiscally conservative Oklahoma.

FEMINIST RECORDINGS

Feminism's influence on the international antinuclear movement was nothing less than transformational. Additionally, women were at the forefront of antinuclear organizing, as exemplified by San Luis

Obispo's Mothers for Peace, who began as an anti–Vietnam War protest group in 1969 and were challenging the potential health impacts of the Diablo Canyon Power Plant just a few years later. Throughout the 1970s and 1980s, women formed affinity groups and feminist collectives at the local level, often making the connection between nuclear power and nuclear weapons explicit. Whereas nuclear weapons constitute the most extreme and potentially destructive formulation of patriarchal violence in human history, nuclear power represents a large-scale misdirection of resources away from basic human needs, a structural violence. Furthermore, radiation poses threats to human reproduction. As nuclear power and disarmament merged as points of antinuclear resistance from the mid-1970s onward, these concerns were articulated in lyrics. Often, the songs appeared on records alongside music critiquing patriarchy, imperialism, racism, homophobia, and other related oppressions.

The Mistakes were a feminist band from Oxford, United Kingdom, who formed after growing disenchanted with the misogynist records on rotation at the local lesbian disco. During their four-year existence, they played numerous gigs on behalf of causes they supported, including benefits for the Campaign for Nuclear Disarmament (CND). The sleeve of their 1981 single, *Radiation/16 Pins,* played on the band's name by scrawling "mistakes will happen" alongside a radiation warning symbol. The Mistakes encouraged listeners to get involved with the CND or the Anti-nuclear Campaign, a national coordinating group dedicated to transitioning from nuclear energy toward renewables. The lyrics of "Radiation" critique the gendered discourse around nuclear power in which male technocratic voices, typically representing themselves as authoritative and rational, downplay health risks while disparaging antinuclear activists as hysterical and misinformed. The Mistakes rejected both the patronizing attitude and the consequences of the chauvinist logic:

> You trust the scientist, he knows best
> A politician, he knows best
> A wing commander, he knows best

Ignorance for all the rest
Well, we don't want your nuclear waste
. . .
We don't want your excrement!

In a similar vein, the UK lesbian feminist duo Ova, composed of Rosemary Schonfeld and Jana Runnalls, diagnosed a plague of "man-made nuclear excrement" on their 1982 track "Nuclear Madness":

We are a race as fragile as bubbles on a living earth
Growing daily conscious that our lives may burst
At the touch of the button from the finger of the man
The god, the song of the Howling Ghost
The triple-headed liar
Conquering, raping, possessing our spirits
Which we now see as the colonized exploitation of the Great Mother
Whose roots are infested with your man-made excrement
Penetrating the pores of our skin
Hanging filth in the air
We are all filled with your radioactive lie

Ova addressed similar ecofeminist perspectives with "The Granny Song," written in 1983 and looking back at the 1980s from a peaceful future perspective. All of Ova's music was released on Stroppy Cow Records, a self-described anticommercial feminist record label.

In the United States, folk singer-songwriter Holly Near founded her own label, Redwood Records, in 1973. The intent was to release politically minded music outside of the mainstream. Former actor Near had grown up in an antinuclear family and became increasingly active in the cause as the 1970s progressed. Her 1979 single, "Ain't No Where You Can Run," was the theme song of her 1979 Tour for a Nuclear Free Future. Inspired by a demonstration against the Rocky Flats Plant, a nuclear weapons manufacturing facility outside of Denver, the song comments on the factory's history of environmental degradation as well as its larger existential threat: "It can get

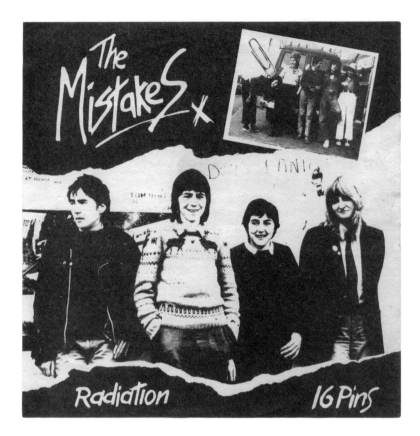

The Mistakes

Radiation 16 Pins

you on the top of a mountain / Or it can ooze under prison doors / It can kill us slow in a lifetime / Or get you fast in a nuclear war!" This song and others were performed on an hour-long broadcast called "The Energy Will Flow: Anti-nuclear Music by Women," which originally aired on KPFA in Berkeley, California, in September 1979 and can now be streamed through the Internet Archive. The program features extended interviews with two activists, Lynne Grasberg of Women for a Nuclear Free Future and Tisha Darthwaite from the East Bay Feminists Against Nukes. Grasberg and Darthwaite cite several reasons for forming women-only antinuclear groups, including the fact that "safe" radiation exposure thresholds are based on the

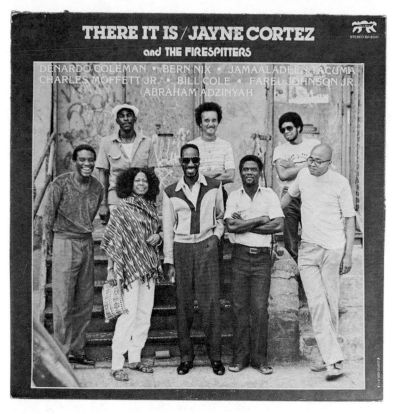

THERE IT IS / JAYNE CORTEZ
and THE FIRESPITTERS

DENARDO COLEMAN • BERN NIX • JAMAALADEEN TACUMA
CHARLES MOFFETT JR. • BILL COLE • FAREL JOHNSON JR.
ABRAHAM ADZINYAH

STEREO BP-8201

bodies of adult cisgender men. Grasberg, a native of Pennsylvania, performs her song "Susquehanna," inspired by the Three Mile Island meltdown a few months earlier. "Susquehanna," and several other songs on the broadcast, including folk singer Kate Wolf's antinuke reworking of the country standard "A Satisfied Mind," Bonnie Lockhart's "The Ballad of Karen Silkwood," and Melanie Motion's "Split Split," have escaped commercial release, making the program a particularly significant resource in the history of antinuclear music. Lockhart published her lyrics in *Out Loud! A Collection of New Songs by Women* in 1978. The song was committed to vinyl the following year by her friends Jeanne Mackey and Penny Rosenwasser on *Meltdown Madness*, a multiartist antinuclear album produced by the mysterious Survival Alliance, presumably a more grassroots

version of MUSE. Nearly as scarce as information about the Survival Alliance is a cassette-only release by Bonnie Lockhart's women's jazz ensemble Swingshift, whose 1981 track "Time Bomb," written by Susan Colson, reflects on the insanity of a world in which one has to even write antinuclear music: "Nuclear power don't belong in no song / In no life, on no planet, and we won't be here long / Reactors and missiles all over the place / Enough to destroy the human race."

Of course, intersecting injustices could also be covered within the space of a single song. African American poet, performance artist, and musician Jayne Cortez came of age in the Black Arts Movement of the 1960s and 1970s. She tied nuclear technology to a larger project of elite domination and white supremacy guaranteed to end in ecological collapse. In 1981's "There It Is," the same villains who "will tell you that there is no ruling class / As they organize their liberal supporters into / White supremacist lynch mobs" can be found "polish[ing] their penises between oil wells at the Pentagon" before they "Pump all of the resources of the world / Into their own veins / And fly off into the wild blue yonder to / Pollute another planet." On "Deadly Radiation Blues," a track from the 1986 album *Maintain Control*, natural disasters are contrasted to those authored by men:

Well, I've seen photos of Nagasaki and Hiroshima
I've heard cries swirling from a chemical plant in Bhopal, India
I've seen radioactive dust in Nevada and Utah
Heard screams echoing from the Ural Mountains too
Now a nuclear reactor is exploding
And I've got those Chernobyl Three Mile Island Blues

On "Tell Me," another track from *Maintain Control*, Cortez interrogates the self-destructive vanity of the entire nuclear project, linking the drives toward erotic and apocalyptic climax with grotesque precision: "Tell me you don't have to fuck yourself on the reactor core of an intense meltdown to show your importance / Tell me that you have no desire to be the first one to fuck into the fission of a fusion of a fucking holocaust."

NUCLEAR FUEL CYCLE / RADIOACTIVE COLONIALISM

Along with the music protesting nuclear power is a disparate body of music critiquing the other stages of the nuclear fuel cycle, beginning with the mining of uranium, continuing through the enrichment, fuel fabrication, and reprocessing stages, and ultimately extending some 250,000 years into the future, when the lethal radioactivity of plutonium has finally spent itself. The concept of "radioactive colonialism" or "nuclear colonialism" describes how the lethal dynamics of colonialism impact Indigenous communities at various stages of this cycle. Approximately 70 percent of the world's uranium reserves lie under Indigenous land. When extractive industries gain footholds in Indigenous communities, the effects can be utterly devastating. In the Diné Nation alone, over five hundred abandoned and highly contaminated uranium mines still require cleanup. In July 1979, an earthen dam holding 1,100 tons of uranium waste and 94 million gallons of radioactive water burst, contaminating the Diné people of Church Rock, New Mexico. The accident was worse than Three Mile Island had been several months before. Even without catastrophic accidents like Church Rock, radioactive contamination has found its way into the land, water, air, homes, and bodies of residents over several generations, resulting in elevated incidences of cancer and other serious illnesses. The back end of the nuclear fuel cycle also involves government and industry attempts to bribe or coerce Indigenous populations into accepting inadequately secured, leak-prone nuclear waste deposits. A further, related component of nuclear colonialism is the siting of aboveground nuclear weapons tests in proximity to Indigenous lands in the American Southwest, Australian outback, Polynesian South Pacific, and elsewhere.

Tribal Voice (1983) was the first of several no-frills cassette releases by John Trudell, a Native American activist, poet, actor, and musician. It speaks to antinuclear concerns while asserting a much broader framework of identity rooted in spirituality, one that actively resists the "technologic nightmares" offered by "Corporate Reich nuclear regimes / Maximizing profit, eating identities / Plundering

TRIBAL VOICE

TRIBAL VOICE

POEMS BY JOHN TRUDELL
TRADITIONAL SONGS SUNG BY QUILTMAN, MADELINE & BARK
Copyright Tribal Voice ©83

AUSTRALIA

STOP

JABILUKA MINE

BUFFY SAINTE-MARIE

Amerikansk
folk- country- och
rocksångerska

AKTIV
MILJÖKÄMPE

Djupt engagerad
i den
nordamerikanska
indianfrågan

MARIE BERGMAN

Universitetsaulan 10/3 kl. 19.00

Förköp: Folkkampanjens informationslokal Svartbäcksgatan 15,
Lundeq, Bokcaféet Arbetarkultur, Musikörat.

Rösta på Linje 3

natural allies / As though the earth was dead." A few years earlier, Trudell had turned to poetry and music after his wife, mother-in-law, and three children died in a house fire. The fire occurred just hours after Trudell had burned an American flag at an American Indian Movement protest. Trudell believed the fatal fire to be arson, retribution for his and his wife Tina Manning's activism over the past decade. He refused to let this unspeakable loss deter him from his activism or from expressing himself. "Living in Reality," a track on *Tribal Voice*, sets several different Trudell poems to traditional music. He describes his captivity following a 1981 demonstration against the Diablo Canyon Power Plant. Despite guards placing him in plastic handcuffs and mocking him, Trudell remained composed, seeing his captors as victims of their own genocidal, authoritarian culture:

Addicted
To their chain of commands
Waiting to be told what to do
Forgetting about me
Thinking
I was just another protester
They were finished with
Never understanding
I am not finished with them
For I am the resistance
And as always I shall return

Which of course he did, with both his activism and his music.

Famed musician, activist, and champion of Native and First Nations rights Buffy Sainte-Marie has also addressed nuclear colonialism repeatedly, including in 1992's "The Priest of the Golden Bull":

Third worlders see it first: the dynamite, the dozers
The cancer and the acid rain
The corporate caterpillars come into our backyards
And turn the world to pocket change
Reservations are the nuclear frontline

Uranium poisoning kills
We're starving in a handful of gluttons
We're drowning in their gravy spills

She continues to write on this topic, as does Klee Benally, a Diné filmmaker, musician, and activist who has been active most of his life protecting sacred Diné lands. His "Song of the Sun" describes the violated earth, stolen lives, and intergenerational trauma of uranium mining and concludes, "There are no words, no words that can right these wrongs."

The Mirarr people, traditional Aboriginal owners of land in and around North Australia's present-day Kakadu National Park, led a broad-based coalition of resistance to the Ranger Uranium company's plan to resume drilling of the Jabiluka mine. Organizing culminated in a successful eight-month-long direct-action blockade in 1998. There were at least two CD benefit compilations in aid of this effort, one full-length and one an EP by a musical collective called Australia containing three different versions of the song "Stop Jabiluka Mine." Both releases incorporate the Jabiluka campaign's main symbol, Kathleen McCann's 1996 design of a black handprint superimposed over a red and yellow radiation warning logo.

Although Australia has resisted adopting commercial nuclear power, its extensive uranium reserves and sparsely populated interior have made Aboriginal lands vulnerable to both mining and, in past decades, aboveground British nuclear tests. Along with the much better-known Midnight Oil, another Australian band that consistently critiqued the nation's nuclear profile was Redgum. Formed in Adelaide in 1975, Redgum included antinuclear songs on many of their LPs. The 1978 track "Servin' USA," drawn from the LP *If You Don't Fight You Can't Win*, reworks the Beach Boys' "Surfin' USA" to critique Prime Minister Malcolm Fraser's willingness to appease the United States' seemingly endless nuclear appetite:

We think Jimmy Carter is a real good bloke
We'll sell him our country for a Ford and a Coke

> He wants our uranium
> We'll give it away
> Tell Malcolm we're servin'
> Servin' USA

Although the US stopped testing nuclear weapons in the South Pacific with the 1963 Partial Test Ban Treaty, the French government continued aboveground testing into the 1990s, despite a brief hiatus in the late 1980s. Herbs, a multiethnic New Zealand reggae band, wrote a handful of songs observing this situation. "French Letter (Letter to France)" gave voice to the Kiwi antinuclear movement in 1982, becoming a radio hit. "French Letter" was reworked several times over the years to mark changes in French testing policy, and in 1985 it was deployed as the flip side of the Herbs single "Nuclear Waste." "Nuclear Waste," however, did not explicitly critique the common practice of surreptitiously dumping radioactive garbage into the Pacific. Rather, the title acted as a metaphor for fallout from the bombs: "Nuclear waste is coming down / It's coming down on you / Oh you better watch out now." Meanwhile, as this music was being made, flotillas of activists were putting their ships and lives in the way of the French nuclear tests, prompting French intelligence to detonate a bomb on Greenpeace's ship, the *Rainbow Warrior*, killing one crew member. New Zealand officially declared itself a "Nuclear Free Zone" with two pieces of mid-1980s legislation, something that remains a rightful point of pride for many New Zealanders.

Across the world, residents of the Orkney Islands archipelago off the northern coast of Scotland opposed the South Scottish Electricity Board's plans to mine uranium just two miles from Stromness, the second largest town in the Orkneys. In 1980, composer Peter Maxwell Davies wrote *The Yellow Cake Revue* in opposition. Maxwell Davies based the name on yellowcake, a concentrated form of uranium powder known for its bright yellow quality. The cabaret piece involves eleven different songs, piano interludes, and theatrical recitations. It was first performed in June 1980 at Orkney's

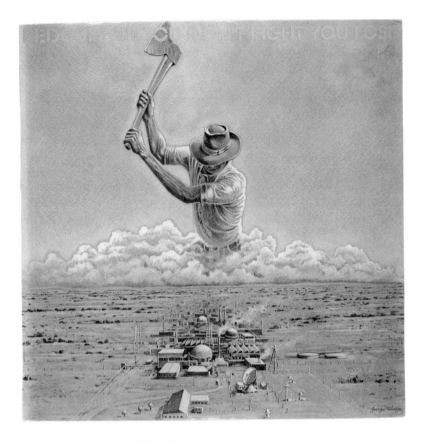

Above: Fast Breeder & the Radio Actors, *Nuclear Waste* 7", Charly Records, 1979; Barry Moore, *Deadly Potion/Lion of the Mountain* 7", Clean Seas, 1983. Opposite: The Sussed, *Don't Swim on the East Coast/I Wanna Conform* 7", Dead Records, 1981.

St. Magnus Festival, with Maxwell Davies playing piano and actor Eleanor Bron reciting the spoken word portions, which satirize interviews for employment in the nuclear industry. Unfortunately, the complete work went unrecorded back in 1980. Recordings of Maxwell Davies's two well-known piano interludes—"Yesnaby Ground" and "Farewell to Stromness"—were eventually released in 2014. In November 2020, *The Yellow Cake Revue* was played in its entirety by members of Fitzwilliam College, Cambridge. This performance was filmed and, as of this writing, remains available to be seen on YouTube. One can't help but be impressed by the black humor of the lyrics and recitations, which starkly contrast with the transcendent beauty of the piano.

Fast Breeder & the Radio Actors, a one-off rock configuration drawn from the ranks of Hawkwind, Gong, and a pre-Police Sting, were also trying to reconcile traditional concepts of beauty with decaying radioisotopes, asking the question "Do you find it attractive to be radioactive?" Their *Nuclear Waste* 45, recorded in January 1978 and sold at antinuke demos that spring, accused nuclear waste of "damaging my lettuces" and "jamming my transmissions," among more standard critiques. Less well known, but also in rock star territory, is *Deadly Potions/Lion of the Mountain*, a 1983 single released by Barry Moore in aid of the Campaign Against Nuclear Waste Dumping. Moore would subsequently find fame as Luka Bloom, but

THIS IS NOT A COLLECTOR'S ITEM

DOUBLE 'B' SIDE

I WANNA CONFORM

DONT SWIM ON THE EAST COAST

The SUSSED

under his birth name he and his older brother, folk musician Christy Moore of Planxty, contributed a song apiece to an Irish compilation bearing the straightforward title *Anti-nuclear 12" Single*. The Early Grave Band rounded out the musicians on this 1979 release. The back jacket included a short essay itemizing nuclear power's many drawbacks, citing the unsolved waste issue as perhaps the most compelling reason to oppose it. The record followed two festivals convened in 1978 and 1979 under the title of "Ireland's 1st/2nd Anti-nuclear Power Show." All this was in response to the government's plans to build a nuclear power plant at Carnsore Point in County Wexford. More festivals would follow. The plant, however, was scrapped, and Ireland has chosen to remain nuclear-free. Nevertheless, inhabitants of the Emerald Isle should probably heed the warning of teenage Dublin punkers the Sussed, whose 1981 song "Don't Swim on the

Al Shade, Jean Romaine, Faron Shade, *Three Mile Island* LP, Aljean Records, 1979; Aaron Este, *Three Mile Island/The Last Resort* 7", Drifting Star Records, 1980.

East Coast" underscores the fact that radioactivity does not respect national borders:

> Don't swim on the East Coast
> There's been a spillage at Windscale
> Slight mishap—a "human error"
> But don't worry, worry
> They say it's not coming our way today

THREE MILE ISLAND (1979)

The antinuclear power movement has broadly been a movement of the left, with roots in the peace, environmental, and feminist struggles, among others. Nevertheless, it is misleading to characterize all antinuclear organizing along strictly ideological terms. Common threats and shared traumas have motivated people to set aside differences and organize into single-issue coalitions. After the 1979 Three Mile Island Unit 2 accident, liberal, moderate, and even conservative demographics were swept into the fight against nuclear power. This was also true of the early 1980s nuclear freeze movement. Similar dynamics can be seen with the music too. Before Three Mile Island, most antinuclear records originated from within the movement. Whether sober or humorous, the songs foregrounded protest. In Three Mile Island's aftermath, a far wider constituency of musicians began grappling with nuclear power's threats. It became more common to express these antinuclear sentiments obliquely or ironically, particularly in genres like punk, metal, and disco. Similarly, nuclear anxieties and buzzwords began contaminating pop lyrics, creating a new generation of nuclear novelty songs of ambiguous sentiment. Still, in comparison to some of the unabashedly jingoistic, pro–atom bomb songs of the 1940s and 1950s, post–Three Mile Island nuclear novelty songs, even ones written in bad taste, often betray an assumption that splitting atoms is detrimental. Take Alice Cooper, for instance, whose 1979 track "Nuclear Infected" claims:

> I want to live on Three Mile Island
> Where things are clean and neat

'Cause we don't have no health freaks cluttering up our streets
I'm nuclear infected
I need something to eat
A China Syndrome salad with plutonium and cheese

The more whimsical side of nuclear-themed music is outside our current scope, but it is worth asking what is behind Three Mile Island's pop culture influence, and why did it turn so many previously apolitical individuals against nuclear power? Three Mile Island was not the first major nuclear accident, but it occurred after a half decade of impassioned antinuclear resistance. When it became clear that a nuclear meltdown could occur in anyone's backyard, the warnings of the antinuclear activists gained more currency. Perhaps even more to the point, Three Mile Island was the first reactor disaster to become a major international media spectacle. The 1966 near meltdown at the Fermi 1 breeder reactor outside of Detroit was almost catastrophic, but world attention was elsewhere and the antinuclear movement itself was experiencing a down cycle. The industry scoffed at author John G. Fuller's assessment that "We almost lost Detroit" (his book's title), although Gil Scott-Heron agreed and turned it into the second of his three antinuclear songs. Additionally, most previous radiological disasters were actively covered up by governments, whether they occurred behind the Iron Curtain, as in the case of the 1957 Kyshtym explosion near the Ural Mountains, or in the capitalist world, as the UK's 1957 Windscale Pile Fire exemplified.

The feature film *The China Syndrome*, released just twelve days before
Three Mile Island melted down, suggested that cover-ups and de-
ception were standard operating procedure for the nuclear industry.
Seemingly taking their cue from the film's villainous operators, Three
Mile Island's controlling utility, Metropolitan Edison (popularly
known as Met-Ed), repeatedly withheld information and minimized
the gravity of the situation. The obfuscations were so transparently
disingenuous as to become immediate source material for an April
1979 *Saturday Night Live* skit called "The Pepsi Syndrome," as well
as for several topical releases from local bands.

York, Pennsylvania, band Arcade's track "Three Mile Island
1" features a nonmusical interview with a fictitious public-relations
hack named "Met-Ed Fred" as he absentmindedly juggles fission-
able materials and babbles untruths. The B-side, "Three Mile Island
2," adds prog-rock bombast and antinuclear lyrics to the mix. Both
songs can be found on the group's 1980 self-released single *The Call
to Arms*, whose profits went to a local antinuclear group, the March
28 Coalition. While scores of local and regional musicians reacted to
the meltdown, Scott "Hot" Shenk of Allentown rockers Daddy Licks
was the most similar to Arcade in that he launched a privately pressed,
prog-rock attack upon Met-Ed with his solo project, the Scott Hot
Band. "Three Miles High (No Nukes)," the A-side of Hot's 45, opens
with bleeps and burps that could have been culled from a low-budget
science fiction thriller score, gradually building into a mid-tempo in-
strumental jam that finally allows for vocals a minute into the song:
"We'll all be Three Miles High when they figure it out / And then
they'll bill us for the answer." It was a prescient observation given that
Met-Ed did, in fact, pass on the costs of the meltdown to the local
ratepayers.

Met-Ed had no disaster plan whatsoever, and Governor Dick
Thornburgh worried that if he ordered a complete evacuation, the
surrounding population would panic. Several days into the accident,
Thornburgh finally implemented a voluntary evacuation for preg-
nant women and preschool-aged children within a five-mile radius.

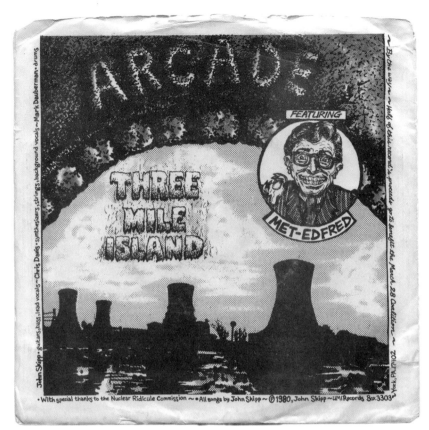

ARCADE

FEATURING

THREE MILE ISLAND

MET-EDFRED

John Skipp~guitars, bass, lead vocals~Chris Davis~synthesizers, strings, background vocals~Mark Dauberman~drums

~By the way~~Half of this record's proceeds go to benefit the March 28 Coalition~~ York, PA. 17402

• With special thanks to the Nuclear Ridicule Commission ~ • All songs by John Skipp ~ ℗1980, John Skipp ~ UMI Records Box 3303

Fourth Man RECORDS

Produced By
Bill Romansky
JMEC-2
Time 4:15

2311 S. 13th Street
Phila. Pa. 19148

THREE MILE ISLAND

℗1979 Fourth Man (ASCAP)

Bill Romansky

WESTA RECORDING CO.

WRP-108-A
(0042)
Side 1
Time: 3:26
Stereo

WESTA
PUBLISHING CO.
B.M.I.
℗ 1979 WESTA
RECORDING CO.
R.D. #3
ETTERS, PA. 17319

THREE MILE ISLAND
(JACK GRIFFITH)
THE TYME-AIRES
FEATURING: JACK GRIFFITH

It was later adjusted to twenty miles. Approximately half the locals chose to read between the lines and evacuate anyway. Radiation had been leaking uncontrolled from the plant long before Met-Ed even admitted to an accident, and contamination continued to escape in lesser amounts over the next few days, along with twelve thousand gallons of radioactive water dumped into the Susquehanna River. Bad as this was, there was also a large hydrogen bubble inside the reactor vessel that, according to expert calculations, was volatile and growing larger by the hour. Al Shade and Jean Romaine, Pennsylvania's "Father and Mother of Country Music," gave voice to this dilemma in their song "Three Mile Island":

> Nuclear power and hydrogen gas its poisons did escape
> But worst of all was the gigantic ball
> What would be our fate
> Should the bubble burst
> May the devil be cursed
> Was the cry throughout this land
> Potter County was made by the hand of God
> But the devil made Three Mile Island

The song, which relies on processed steel guitar and the studio wizardry of Jean's multitracked vocal harmonies to evoke both civil defense sirens and angelic overtones, was recorded in Nashville, Tennessee, while the melted corpse of Unit 2 was still smoldering inside the three-foot-thick concrete walls of the containment dome. Shade and Romaine released the song on their own Aljean record label as both a 45 and the title track of their 1979 album.

A handful of other Pennsylvania country-and-western acts released pro-Jesus, anti–Three Mile Island records, but nothing was quite like Willis Meyer's "Headin' for Armageddon." This 45 A-side begins with a spoken introduction complaining, "It's hard to keep on smiling when you know there's a Three Mile Island right outside your door." Meyers spends the next 165 seconds lambasting humanity for forgetting the Ten Commandments and befouling God's creation

United Mine Workers Journal no. 4, 1979, cover art by Stephen Wagner.

with atomic weapons and nuclear power. While doing so, a low but persistent Atari 2600 sound effect, presumably intended to suggest radiation, keeps his gospel lively. It was a tour de force for the elderly Meyers, who, until retiring just a few years before, had earned his living operating a drill press in nearby Allentown, Pennsylvania. Weekends found Meyers and his band, the Bar-X Ranch Boys, holding down multiple residencies on local radio stations or playing the occasional county fair. The Philadelphia-based Arzee Records issued a much different version of the song by the Gospel Blenders, this time as a gospelized B-side omitting the spoken intro. Then, in 1990, long after the song had been forgotten, former Bill Haley & the Comets pianist Joey Welz made a surreal, green-screen-abusing music video for *his* version of "Headin' for Armageddon" and sent the 45 off to do battle in the country-and-western charts.

What the hell was happening with this song? Turns out that "Headin' for Armageddon" was cowritten by James E. Myers, who, back in the 1940s, released his own compositions on his label Cowboy Records, alongside songs by a pre-Comets Bill Haley and Willis Meyers himself. James E. Myers also did some acting, including a role as an extra in, of all films, *The China Syndrome*, where he plays a thug employed by the nuke industry to arrange violence against whistleblowers, clearly a reference to Karen Silkwood. Under the pen name of James De Knight, Myers achieved his primary claim to fame as a cowriter of Haley's "Rock Around the Clock." To say he cowrote the song is to slightly overstate the matter; he effectively retitled Max C. Freedman's "Dance Around the Clock" and then laid claim to the song's copyright in the process. It was a gravy train that Myers would never forsake. In fact, Myers and pianist Joey Welz, mentor

and pupil respectively, would cash in repeatedly over the decades, inflicting such dubious copyrighted endeavors as "Rock Around the Clock (The Heavy Metal Version)" and "Rock Around the Clock Forever (aka The Rap Version)" on new generations. Nor did they stop there. Myers operated a Rock Around the Clock Museum out of his Florida house; Joey Welz, now in his eighties, continues to do the same out of his Lititz, Pennsylvania, home. Visit at your own risk. Either way, it might be worth pointing your browser in the direction of his "Headin' for Armageddon" video on YouTube to get a look at Welz's signature keytar and the stock footage of cooling towers that are supposed to be Three Mile Island. (They aren't.)

Three Mile Island's four-hundred-foot cooling towers, two per reactor, became an overnight symbol of the perils of nuclear power, rivaling the mushroom cloud's ability to evoke radiological dread. Occasionally, both symbols overlap to warn of something along the lines of "a Hiroshima in Harrisburg." This was the angle that the *United Mine Workers Journal* took for their May 1979 issue. The front cover had a disembodied Jimmy Carter head suspended, Wizard of Oz–like, amidst a mushroom cloud rushing upward from all four cooling towers. The surrounding sky was a fiery hellscape. Underneath the image and below the surface of the ground, from within a rich vein of coal, the caption reads: "Three Mile Island: Coal Is Still the Answer." The back cover of the journal promotes United Mine Workers of America Vice President Sam Church's 1979 single *There Is No Better Way/Black Gold*, written and released with the help of his wife, Patti. The single, which was available via mail order and distributed nationally, was intended to benefit the Organizing Relief Fund for miners striking for UMWA contracts. Previously, Church, the son of a West Virginia coal miner turned barber, had performed only "in church and at parties." Upon hearing the record, it's clear why his singing career had remained limited. This is not to say the songs themselves are bad. The backup vocals are quite good, especially the intro to the song "Black Gold," which begins with (I think) Patti twice singing "Evacuate" over the steel guitar intro before Church warbles, "America take warning /

There's something you should know / There would be no Three Mile Island / If we were burning coal." At this point, the backup vocalist adds an almost-whispered "Black gold" before Church continues,

> They don't think of radiation
> Where do we put the waste
> Ain't you see the danger
> This power does create
> Even the smallest accident and we must evacuate
> But it was God's intention
> Black gold should be our fate

In 1981, Harrisburg activists sponsored a "Rock Against Radiation" concert with local bands on City Island, the Susquehanna River's sixty-three-acre "recreational jewel" located a dozen miles upriver from the other, more infamous island. But no album came out of it, and in contrast to some other antinuclear flashpoints around the world, there is no extant compilation album produced in Three Mile Island's aftermath featuring songs by local or regional musicians. Instead, scores of 45s, album tracks, demos, and "fugitive recordings"—some of which we described above but far, far more than we have mentioned—provide these perspectives in a more scattershot manner. One of the most popular of these tracks was by Maxwell, a central Pennsylvania multiracial, working-class, disco and funk act whose first single, "Radiation Funk," got quite a bit of airplay on local stations in the months after the accident. According to the band, their record even displaced Donna Summer's "Bad Girls" during the summer of 1979. The song was written by member Charles "Marty" Moore, who lived in Columbia, Pennsylvania, a few miles downriver from Three Mile Island. Until shortly before the accident, Moore actually worked as a contractor at the plant. His lyrics speak to a number of concerns facing central Pennsylvania locals circa spring 1979—evacuation preparedness, potential contamination of the milk supply, and getting back to the disco:

> I've got the bubble in my backyard

And the water from my faucet is mighty hot
If we can only get over this hump
Meet you at the disco, radiation bump
Radiation funk
Sure ain't no junk
Radiation melt
Everybody fall out

THE NUCLEAR REGULATORY COMMISSION

Back in 1971, three hundred hippies steered a raggedy fleet of school buses and VW vans from Haight-Ashbury to rural Tennessee, where everyone pulled together funds to buy the land that would become the Farm. Turning a chunk of wilderness into a soybean farm capable of sustaining hundreds of residents required considerable resourcefulness. Residents of the Farm worked long days in the bean fields and built their own homes, school, bakery, health clinic, printing house, and radio station. Musical acts were hatched, including the Farm Band. The Farm Band had an amazing sound system that they used when playing free shows at recreation centers and parks across the country, acting as support for the Farm's visionary leader, Stephen Gaskin, who lectured about spirituality and community. They managed to self-issue four LPs and a handful of 45s during the 1970s as either the Farm Band or the Tennessee Farm Band. In summer 1979, they put out a single on their own label, Farm Records, titled "Shut Down." The song decried the cooling towers creeping into their rural landscape and characterized nuclear power as a "loaded weapon in the hands of a government of fools / Owned by multinational makers of rules." In 1979–80, they linked up with the Pacific Alliance/Abalone Alliance protest circuit by providing sound for hire at antinuclear rallies. It was at one of these, after setting up for a Jackson Browne, Graham Nash, and Bonnie Raitt concert, that Nash and Raitt persuaded them to play a set. The Farm Band treated the crowd to "Shut Down" and a few other songs, and as the story goes, a new name change came into being after this show. While hanging out talking

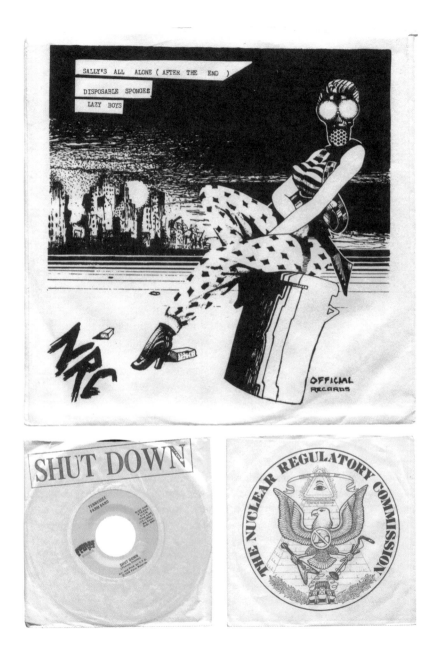

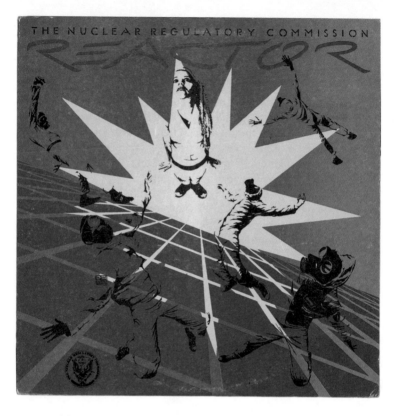

about Three Mile Island, somebody said, "'Where's the Nuclear Regulatory Commission? . . . It's like they're not there. We need another NRC.' And everybody just looked at each other, and it was one of those moments, and we said: 'We'll be the NRC!'"* And so, they were. This new identity marked a break with their psychedelic, jam-band past by embracing new-wave sounds and aesthetics. The NRC was more than just a clever band name or agitprop theater, although there was certainly a high quotient of the latter given the white Tyvek suits, hard hats, and gas masks they often wore onstage. Most NRC songs challenge various aspects of nuclear power. "System Failure" begins, "Man has created a vast array of systems for the preservation of the status quo" before referencing the 1975 Brown's Ferry accident:

*This anecdote is from the "Electric Tofu" episode about the Farm on the *Gravy* podcast. Betsy Shepherd, producer, "Electric Tofu," *Gravy*, August 15, 2019, podcast, 26:31, https://www. southernfoodways.org/gravy/electric-tofu.

"There's a bad situation down at the radiation station / Somebody's candle caught fire to the insulation." "Hot Fish" deals with dumping nuclear waste into the food chain, while "Disposable Sponges" references the despicable practice of using untrained, unsuspecting laborers to do radiation cleanup work. "Fax" takes inventory of some of the nation's missing weapons-grade uranium.

On the road, the NRC packed the Nuke Buster, a portable radiation detector invented by colleagues at the Farm electronics lab. The Nuke Buster generated headlines when the band was playing a rally near the Washington Monument. Farm children were visiting the Smithsonian's Hall of Minerals when the Nuke Buster registered a high background radiation around an ore exhibit. This led to the ores being removed until leaded glass could be installed to shield visitors. The NRC also put the Nuke Buster to use embarrassing the Tennessee Valley Authority (TVA) over their abandoned Edgemont uranium mine at the same time the utility was trying to win a rate hike. But perhaps the most compelling example was the lawsuit that the NRC and their "Director of Reactor Research" (aka lawyer) Albert Bates brought against their namesake in Washington, DC. The resulting case, *NRC v. NRC*, argued that the (pronuke) NRC violated the Atomic Energy Act by granting the TVA's new Sequoyah Nuclear Plant a license. The concern of the (antinuke) NRC, which the (pronuke) NRC admitted was correct, was that the Sequoyah's containment structure was excessively thin. This so-called "Eggshell Containment" was unable to withstand a hydrogen explosion only one-third the size of the one that occurred in the early stages of Three Mile Island. Ultimately, despite all the facts on the ground favoring the (antinuke) NRC, the (pronuke) NRC was ruled as immune to the lawsuit.

Soon, the band began moving in other directions, creating a script for an antinuclear sitcom with the backing of the Abalone Alliance and laying down tracks for another album, some of which addressed nonnuclear topics. But their second act was not to be. The Farm itself had come to a crossroads, and a financial crisis compelled

neue Lieder und Gedichte

aus

Kaiser-
augst

Wyhl

Fessen-
heim

Freundschaftshaus
Marckolsheim

DREYECKLAND

herausgegeben von den Badisch-Elsässischen Bürgerinitiativen und dem Trikont-Verlag, München

A-Wärgg-Gländ Kaiseraugscht

bsetzt

Aernsond Uern

BSETZERLIEDER

mer sin eifach wieder do !

a transition from a completely collective to a cooperative form of ownership. The population decreased rapidly, and the Nuclear Regulatory Commission dissolved into the mists of time.

EUROPE

Across the Atlantic Ocean, antinuclear power sentiment was rising. On one side were the economic, political, and social elites; on the other, the counterculture. The movement was built on multiple foundations, including the remains of the student revolts of the 1960s, various expressions of cultural regionalism, the emerging environmental movement, and assorted struggles for democratization, decentralization, and increased worker control.

DREYECKLAND: AWARENESS OF COMMON HISTORY, CULTURE, AND LANGUAGE THROUGH ANTINUCLEAR STRUGGLE

In 1973, the French government approved a permit for the construction of a lead factory near Marckolsheim. Just across the Rhine, West Germany wanted to build a nuclear power plant at Wyhl, and not far to the south, the Swiss government was trying to build a nuclear power plant at Kaiseraugst. These struggles became a common denominator for the nascent environmental movement in this three-country region, known as Dreyeckland. Antinuclear organizing greatly increased awareness that the Upper Rhine region had a common cultural history and language, despite the geographic boundaries of three different countries. International cooperation began a couple of years earlier, when antinuclear groups convened in Fessenheim, France, in April 1971 to protest construction of a nuclear reactor, and then again in December 1971 in Strasbourg, France, to organize an occupation of a planned reactor site. These two nuclear reactors were eventually built but were permanently shut down in 2020.

In the years 1974 and 1975, activists in this region undertook several direct actions that were key to the development of the European environmental movement. On September 20, 1974, French, German, and Swiss residents successfully occupied the site

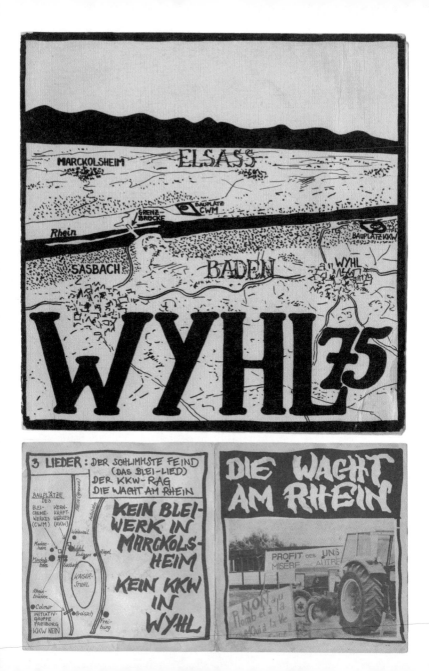

of the planned lead factory near Marckolsheim, a small French village on the Rhine bordering Germany, that would have produced extreme amounts of pollution. Four months later, the French government stopped construction of the plant. A few weeks after that, on February 18, 1975, a nuclear power plant construction site in Wyhl, Germany, was occupied by a few hundred protestors. Wyhl was just six miles east of Marckolsheim. The event made international news two days later when 650 police officers cleared the site with a water cannon and batons. On February 23, more than twenty-five thousand antinuclear activists, including those from far outside the region, succeeded in reoccupying the site. A village was formed in the forest, created by *Bürgerinitiatives* (organized citizen's initiatives—local grassroots action groups that were an important part of the militant West German left in the 1970s and 1980s), and this village was permanently inhabited by people from the region and beyond. Das Freundschaftshaus, a circular wooden building that could hold up to five hundred people, was built there. Capacity was often exceeded due to its popularity. The Volkshochschule Wyhler Wald, an alternative educational center in the village that hosted lectures, concerts, readings, and discussions, was also popular.

Antinuclear forces won the first of many lawsuits against the construction permit less than a month later. In November 1975, as part of the legal agreement, the citizens' initiatives left the site; from that point forward, it was jointly monitored by the citizens' initiatives, the government, and the Kernkraftwerk Süd in order to ensure construction didn't begin. This arrangement was a prerequisite for negotiations with the state government. By the end of 1983, plans for the Wyhl nuclear power plant appeared to be off the table, but it was not until 1994 that the project was officially terminated.

Four records were released by the West German Trikont label about the fight against the power plant at Wyhl: two singles, *Die Wacht am Rhein* (1974) and *Wyhl 75* (1975), and two compilation LPs, *Marckolsheim/Wyhl: Lieder im "Frendschaft's Huss"/Chansons dans la "Maison de L'amitié"* (1975) and *Neue Lieder und Gedichte aus*

Dreyeckland (1978). While the earlier records came from the circle of urban, left-wing nuclear opponents (such as Berlin lefty-bard Walter Mossman, who will be looked at later), the 1978 double LP was intended as a broader showing of the music in the Kaiserstuhl region's antinuclear movement. It contains mainly songs by Kaiserstuhlers. It also reflects the cooperation that had begun among the people of the Alemannic-speaking "triangle country" of Baden (Germany), Elsàss* (France), and northern Switzerland. The environmental and antinuclear struggles of those years reawakened the common history, culture, and language of the region, long-buried by modern statecraft.

KAISERAUGST

Fifty miles south of Dreyeckland, near Basel, a nuclear power plant was planned on the Swiss shore of the Rhine. Work began without notice on Monday, March 24, 1975. Over the long Easter weekend beginning on March 30, five hundred people occupied the site. Then, a week later, fifteen thousand people gathered at the occupied site to make their displeasure with the nuclear power program clear. On May 28, a concert was held at the occupied site by a number of well-known regional performer-activists. The concert was recorded, and a few songs were released by GAK (Gewaltfreie Aktion Kaiseraugst, or Nonviolent Action Kaiseraugst) on a 7" with the appealing title *Bsetzerlieder* (Occupier songs). Again, almost everything is sung in Alemannic. The occupation ended on June 14 after authorities offered negotiations and a halt to construction.

From August 26 to 28, 1977, Graben-fest was held near the planned nuclear power plant in Graben, Switzerland. A recording of the concerts was released, with cover art featuring a photo from the festival and the center labels on the vinyl record depicting an anthropomorphic cooling tower attired for a proper Dionysian bash, artwork that mirrors the poster promoting the event. The Grabenshouters, Tinu Heiniger, and Aernschd (Ernst) Born contributed the majority of the tracks.

The following year, again in Switzerland, an attempt to occupy

Alsace in the Alemannic language.

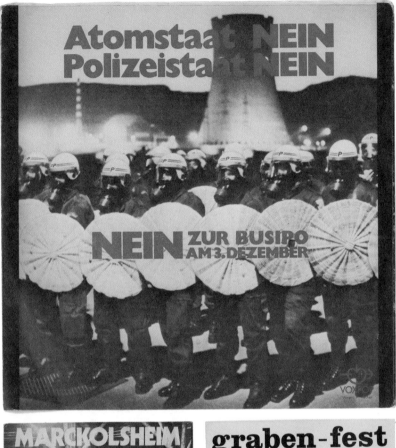

Atomstaat NEIN
Polizeistaat NEIN

NEIN ZUR BUSIRO AM 3. DEZEMBER

MARCKOLSHEIM
Lieder im 'Frendschaft's Huss'
Chansons dans la 'Maison de l'Amitie'

graben-fest

the construction site of the Gösgen nuclear power plant was prevented by nine hundred riot police equipped with an arsenal of tear gas and water cannons. A picture of this overwhelming show of police force adorns the cover of the 1978 7" single *Atomstaat NEIN, Polizeistaat NEIN* (No nuclear state, no police state). The back cover documents the police abusing a protester. The A-side, "Tango BuSiPo," critiques the proposed Bundessicherheitspolizei Referendum, which allowed for increased state security crackdowns on antinuclear protesters and other "terrorists." This ballot measure was defeated.

In the Swiss context, Ernst Born was the most popular musician at the center of antinuclear organizing in the region. Born was born in Zurich in 1949 and grew up in Basel. During his youth, he began to write songs, first in German and then increasingly in Basel dialect. His lyrics dealt mainly with social and ecological issues. In 1975, Born participated in the occupation against the nuclear power plant in Kaiseraugst and earned a reputation as the house singer of the antinuclear movement. After the successful occupation, Born remained active in different cultural projects: he is known for being a rock musician, playwright, satirist, director of the Kulturpavillon in Basel, and more. From 2007 to 2014, Born was executive director of the associations NWA (Nie Wieder Atomkraftwerke, or Never Again Nuclear Power Plants) and TRAS (Trinational Nuclear Protection Association). From 2014 to 2021, he was curator of the Dokumentationsstelle Atomfreie Schweiz (Documentation Center Nuclear-Free Switzerland). He still writes songs on environmental topics today.

Born's classic on Kaiseraugst, "d Ballade vo Kaiseraugscht," is a nine-minute history of Swiss nuclear power beginning in November 1957—when "a majority of responsible men" pass a law in favor of nuclear power—and ending with popular resistance and the occupation of Kaiseraugst:

Es sin hunderti ko, s het e Dorf gä dört us
In dr ganze Region hän is Lyt unterschtützt
Und jetz müen d Behörde verhandle mit uns
Me gseht, was mer gmacht hän het gnützt

BAUER MAAS

LIEDER GEGEN ATOMENERGIE

OSTERSONGS

62 63

gegen die Bombe

33 pläne

DAS LIED DER GRÜNEN

...und der Mensch?

Best.-Nr: 10-79-1

Grundentwurf Grafikwerkstatt - Bielefeld

Clockwise from top: Duchemin, Lesquer, and Guiho, *Nucléaire, ya pas d'danger!* 7", no label,
date unknown; Bo Bo, *Prolet-Rock* LP, Bohrmaschine Bornheim, 1979; Carlsberg, *Demonstration
Time (No Nukes)* 7", CNR, 1982.

. . .

Und wem mir öppis erreiche wän
Schaffe mer eins, zwei, vyli Kaiseraugscht

Hundreds have come, the village belongs to us
In the whole region people are supporting it
And now the authorities have to negotiate with us
It is clear, what we did was successful

. . .

And when we want to achieve something
We have to create one, two, many Kaiseraugsts

KAN GOANAG HA KANN: A SONG OF HOPE AND BATTLE (IN REGIONAL LANGUAGES)

The French-German-Swiss border region was not the only place
where dialect played an important role in the antinuclear movement.
This was also the case in northern France in the second half of the
1970s, in the resistance against several nuclear reactors. Plogoff was
the proposed location for a nuclear power plant in the French re-
gion of Brittany. Thanks to massive popular resistance, bolstered by
Breton culture and language, the newly elected French prime min-
ister Francois Mitterand canceled these plans in 1982. (Although
Mitterand was elected on the promise of phasing out nuclear en-
ergy, aside from Plogoff he actually presided over the expansion of
the French nuclear program.) The struggle against Plogoff inspired
a handful of releases on cassette and vinyl. Alan Stivell's song "Beg
ar Van" (The point of the van) was one such song. Stivell is a French,
Breton, and Celtic musician who modernized traditional Breton mu-
sic and sang in the Breton language. Stivell explains that on "Beg ar
Van" he deployed choirs, electric guitar, and saxophone to create an
ominous mood, which "goes beyond the events of Plogoff, to become
a kind of death howl, the death of a culture, of a civilization."

Popular Breton folk group Tri Yann devoted the second side of
its 1981 album *An heol a zo glaz* (The sun is green) to the struggle in

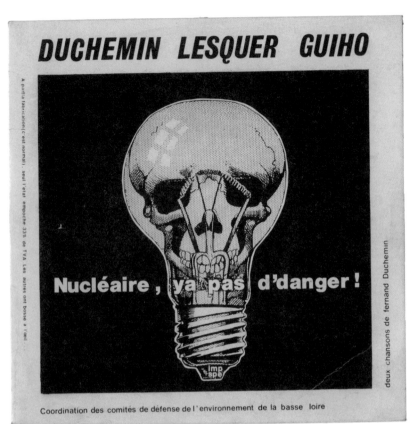

DUCHEMIN LESQUER GUIHO

Nucléaire , ya pas d'danger !

A partir fabrication (c'est normal), seul l'état empoche 33% de TVA. Les autres ont bosse à l'oeil

deux chansons de fernand Duchemin

Coordination des comités de défense de l'environnement de la basse loire

CARLSBERG

145.005
CNR

DEMONSTRATION TIME (No Nukes)

Es ist nicht mehr fern
Unser Land

bobo
Prolet-Rock

Plogoff. Their song "Kan an heol" (Song of the sun) celebrates the Pentecost in 1980, when one hundred thousand people joined the villagers during the Plogoff protests at Pointe du Van:

> *Kant mil'zo enemgavet*
> *Kant mil kounnaret*
> *Kant mil oll war Veg ar Van*
> *Kan ha klemm ha kann*
> *Kan trec'h ha korroll d'id heol*
> *Kan goanag ha kann*
> *Kan ha kann*

> One hundred thousand gathered
> One hundred thousand in anger
> One hundred thousand, all on the Pointe de Van
> Singing and crying and fighting
> Victory song and dance to you, sun
> A song of hope and battle
> Singing and fighting

Other Plogoff-related releases include "Plogoff," the B-side of a 1980 single by French pub rockers Fernand L'élcair, and Radio Plogoff's *On a Gagné*, a spoken-word cassette release, which has recently been reissued.

In the 1990s, Wilfried Staake sang his song "Leukamie in de Elvmarsch" in Platt-deutsch, a dialect spoken in parts of northern Germany and Denmark. The song describes a childhood leukemia cluster in a small village near the Krümmel nuclear power plant and nuclear research center. In 2009, he performed it at the demonstration against Krümmel in commemoration of Chernobyl. The song's main message is: "*Gegen Angst hölpt keen Chemotherapie*" (There is no chemotherapy for fear). Staake asks: "*Is dat de Pries fört Fortkommen / Dat Menschen dorüm starvt / Dat wie Strom hebbt jümmer und över-all?*" (Is that the price for progress / That people are starving / So we have electricity everywhere and at all times?)

BROKDORF—
EINE VISION

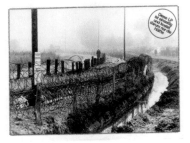

lemoiz gelditu

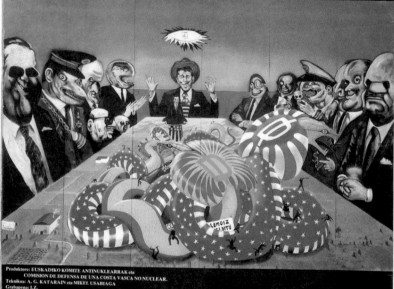

Produktore: EUSKADIKO KOMITE ANTINUKLEARRAK eta
COMISION DE DEFENSA DE UNA COSTA VASCA NO NUCLEAR.
Teknikoa: A. G. KATARAIN eta MIKEL USABIAGA
Grabapena: I.Z.
Banatzaileak: I.Z.—OTS— ELKAR — TIC.TAC
Argitaratzaile: TIC.TAC
ZUZENEAN EGINDAKO GRABAPENA
grabación realizada en directo
D.L.NA1256—1980

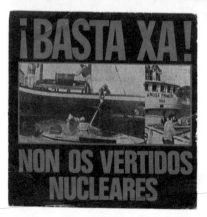

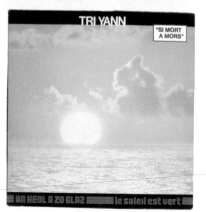

LEMOIZ GELDITU

In contrast to regionalism in Dreyeckland, regions in France and
Spain explicitly sought political autonomy or even secession, as is the
case in the Basque Country and Catalonia. The importance of lan-
guage in those regions fighting for greater autonomy is also shown
by the underground comic *Asterix and the Nuclear Power Plant*.
Asterix und das Atomkraftwerk was first created in Vienna, Austria,
in 1978 by cutting up existing Asterix comic books, rearranging se-
lected panels, and adding a new narrative into the speech bubbles.
The story of the successful Gaulish resistance to a nuclear power
plant resonated with the antinuclear movement. Pirated copies were
circulated in various German towns even before the first German
edition was stopped through legal action by the copyright owners of
the Asterix brand. The volume was translated and adapted to Dutch,
French (different editions in Switzerland and France), and various
languages in Spain. The first translation appears in 1980 in Castilian
Spanish, *Asterix ya Central Nuclear*, and shortly after comes a Basque
translation, *Asterix eta Zentral Nuklearra*. Editions also appear in
Catalan (*Asterix i la Central Nuclear*) and in Galician (*Asterix y las
Nucleares*). In 1994, another reprint of the first Castilian Spanish
edition was coedited by Soroll, which means "sound" or "noise" in
Catalan. Soroll, founded in Valencia in 1992, is an anarcho-punk
record label, publisher, and distributor of vinyl, cassettes, books, and
fanzines. All the Asterixes in Spain, except for one Catalan edition,
center around the struggle against the construction of the nuclear
reactors at Lemoiz (Lemoniz) in the Basque Country. Construction
of the two reactors started in 1972, and beginning in 1974 there were
large mass campaigns against construction, as well as bombings by
ETA—the armed wing of the Basque separatist movement—against
the companies and management behind the nuclear plant. The vio-
lence came from both sides, with police attacking protestors, and at
a demonstration on the Pentecost in 1979, the Guardia Civil shot
and killed environmental activist Gladys del Estal. Construction was
stopped on May 5, 1982, after yet another attack by ETA. After

an election victory later that year, the PSOE (Spanish Socialist Workers' Party) proclaimed "a significant reduction of the nuclear program." Lemoiz 1 and 2 were among the six reactors canceled.

The double album *Lemoiz gelditu* (Lemoiz stoppage) was released at the end of 1980. It compiles performances and speeches that occurred during the Herrikoi Topaketak (Popular Encounters) festival, which was held on November 8 and 9, 1980, at the International Fairgrounds of Bilbao. Herrikoi Topaketak was organized by the Euskadi Antinuclear Committees and the Commission for the Defense of a Nonnuclear Basque Coast. It brought together more than three hundred artists from the seven Basque provinces. Among those in attendance were musicians, painters, sculptors, photographers, filmmakers, theater groups, mimes, poets, and craftspeople. On the back cover of the album, there is a reproduction of a mural painted during the festival by Vicente Ameztoi, Jose Luis Zumeta, and Carlos Zabala. It stands nearly five meters high and seven meters wide and caricatures politicians, military figures, and businessmen, all fawning over two giant snakes decorated as the United States and Spain, which are being mounted and attacked by the small figures of the protest movement. It is currently on display at the Bilbao Fine Arts Museum in a room it shares with posters, stickers, and newspapers from the struggle. The musician Iskandar Rementeria put it best: "The mural is monumental, not only because of the size of the artwork, but also because it synthesizes the intent of a social movement."

BROKDORF: *DAT DING KUMMT HIER NICH HER* (THAT THING DOESN'T COME HERE)

Following Wyhl, Brokdorf became the primary focus of the German antinuclear movement. The construction of Brokdorf began suddenly in August 1976. Over the following decade, it was the scene of multiple violent confrontations between militarized riot police and protestors. Like the situation in Wyhl, the struggle against the Brokdorf nuclear power plant was documented in song. Records were released from within the anti-Brokdorf movement and in support of it. In late 1976, *Atomanlagen in Liedern und Gedichten ihrer*

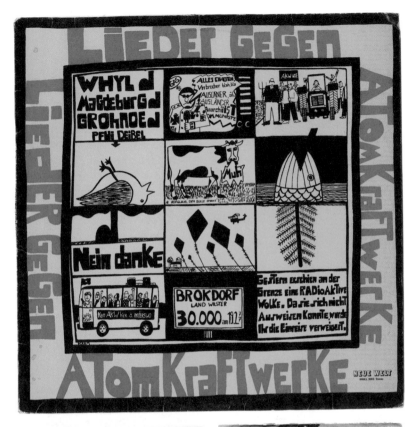

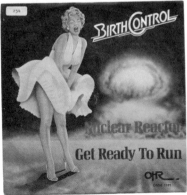

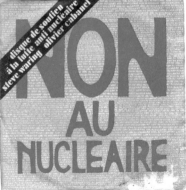

norddeutschen Gegner was released, with most of the content—songs, poetry, and spoken word—in local dialect. The album was followed by Kernbeisser's LP *Brokdorfer Kantate*, which sets Peter-Paul Zahl's extended poem about nuclear power and state repression to challenging, progressive music. The front cover dramatizes the repression of the atomic state with an image of a helicopter surveilling protestors. The back cover shows the usual names and snapshots of musicians. Among the photos is an image of cops in riot gear, identified with the caption "This is the Choir."

"Brokdorf Sinfonie," an intriguing small-press 45 by Der Grüne Engel, surfaced in 1981. The sleeve promised sales would help the fight against cancer. The contents are rather avant-garde: amateur electronic music with antinuclear lyrics sung by both a man and a child. The B-side, "Radioactivität," adds a female vocalist and an additional layer of disco funk to the unpolished synth pop. It may or may not have a loose relationship to the Kraftwerk song of the same name . . . you be the judge! Perhaps the spirit of the project is best summarized by a question posed on the back of the record's sleeve: "*Lieber Herr Papst, wenn ich durch das Atomkraftwerk sterbe, werde ich dann heilig?*" (Dear Pope, if I die at the hands of the nuclear power plant, will I become holy?). Several more records were issued in relation to the campaign: *Brokdorf: Eine Vision*, a one-sided spoken-word album by author Jutta Heinrich; the compilation album *Wehrt Euch!* (Resist!); and another compilation album released in solidarity with people arrested in the February protest, *Wo Unrecht zu Recht wird, wird Widerstand zur Pflicht* (Where injustice becomes law, resistance becomes duty). The Brokdorf nuclear power plant was finally shut down at the end of 2021.

OUR OWN VOICE AND WALTER MOSSMANN

Trikont publishing house was founded in Munich in 1967 and was dedicated to left-wing intellectual content. The name was derived from the geographical concept of the Trikont, referring to the three continents of the Global South: Asia, Africa, and South America.

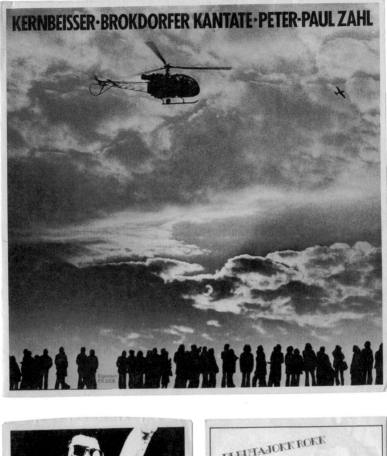

KERNBEISSER · BROKDORFER KANTATE · PETER-PAUL ZAHL

Eigelstein
ES 2005

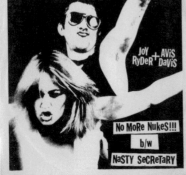

JoY RyDeR + AViS DaViS

No MoRe NukeS!!!
b/w
NaSTY SeCReTaRY

PLBUTAJOKK ROKK

JORM

BERNARDO LANZETTI

GENERAZIONE NUCLEARE

CAPRIFISCHER

ZAZA

DIE SELTSAME REISE

D'JACKSON SURIAM

SOS NUCLEAIRE

Igor Nikolayev

CHERNOBYL GUY

sheree

8068

featuring
RONALD REAGAN
and
MICHAIL GORBATSCHOW

RONNIE-
TALK TO
RUSSIA!

›GLASNOST-MIX‹

T.I.M.E. C.A.P.S.U.L.E.

MR. NUKE IS A FOOL

Because of music's democratic potential and relevance to the po-
liticized counterculture, a music publishing arm was added in 1972:
Trikont-Unsere Stimme (Our Own Voice). The publishing house
went bankrupt in the early 1980s, but the record label has proven
more resilient, continuing to release music today. The first record the
label released, in 1972, was titled *Wir befreien uns selbst* (We liber-
ate ourselves) by Arbeitersacher München, one of the many new
MEKs (*Mobile Einsatz Kapellen*, or mobile street bands, wordplay
on the official MEKs, an abbreviation for *Mobile Einsatzkommandos*,
or mobile German police units). This record included songs about
the workers' struggle at BMW, squatting, the plight of immigrant
workers, and women's rights. Almost immediately, recordings and
performers from the emerging antinuclear movement found a home
at Trikont. In 1976 and 1977, Trikont published two newspapers on
political (street) music, with an intention to create a regular monthly
publication, although this never came to fruition.

One of the central antinuclear activists to release material on
Trikont was singer-songwriter Walter Mossmann. Mossman was
exposed to protest music through political events in Iran, Portugal,
Spain, Greece, and Chile. He wrote critically about music for the
Trikont newspaper, criticizing the enthusiasm among leftists for the
"exotic sounds" of Latin American music, finding the uncritical em-
brace of heroism and victoriousness inappropriate for the German
context. Instead, he made completely different demands on the ad-
aptation of popular song: "It must be antipathetic, in no case trium-
phalist. . . . But hope also has nothing to do with showiness." For
Mossmann, songs should have an immediate use and value in the
context of the political struggle. Furthermore, they should belong to
everyone. That is why he called them *Flugblattlieder*, or leaflet songs;
music of this type could circulate freely and be continually adapted
to new circumstances, much like the anonymous popular songs
of the French Revolution and the Peasants' Wars. Due to topical
events—Wyhl, Marckolsheim, Kaiseraugst—Mossmann wrote songs
in the Alemannic dialects in the 1970s, especially the Kaiserstühler,

Alsatian, and Badener dialects, as well as in Schwiizerdütsch (Swiss German). Mossmann wrote what is probably his best-known song, "Die Wacht am Rhein," as part of the occupation movement at Wyhl. Here, the original nationalist jingoism of the "arch enemy France" was inverted in the service of multinational cooperation and struggle:

Im Elsaß und in Baden
War lange große Not
Da schossen wir für unsre Herrn
Im Krieg einander tot
Jetzt kämpfen wir für uns selber
In Wyhl und Marckolsheim
Wir halten hier gemeinsam
Eine andere Wacht am Rhein
Auf welcher Seite stehst du?
He! Hier wird ein Platz besetzt
Hier schützen wir uns vor dem Dreck
Nicht morgen, sondern JETZT!

In Alsace and Baden
There was great need for a long time
We shot for our masters
Shot in the war each other dead
Now we fight for ourselves
In Wyhl and Marckolsheim
We hold here together
Another guard on the Rhine
Which side are you on?
Hey! Here we occupy a place
Here we protect ourselves from the dirt
Not tomorrow, but NOW!

Beginning in 1977, Mossman made frequent stops in Gorleben to protest with the Wendlanders against the planned repository for radioactive waste. For them, he wrote the well-known "Lied vom

Lebensvogel" (Song of the bird of life), also called "The Gorleben Song," the original music of which was written by American folk singer Phil Ochs.

ATOMKRAFT? NEJ TAK!
SCANDINAVIAN ANTINUCLEAR MUSIC

Denmark had a great interest in developing nuclear power in the 1970s. Massive antinuclear protests followed, and as a result, the Danish government made the decision to move away from nuclear dependency. In 1985, the Danish parliament passed a law prohibiting nuclear energy production in Denmark and began developing wind energy. However, nuclear power remains close by—in Sweden, across the narrow Øresund strait, the Barsebäck nuclear power plant's first reactor went online in 1975. Two years later, it was followed by a second reactor. Barsebäck was a mere twelve and a half miles from the Danish capital of Copenhagen. The proximity was regarded as a tremendous provocation. In 1977, with Danish public opinion mostly opposed to nuclear power, the largest Danish antinuclear organization, Organisationen til Oplysning om Atomkraft (OOA), prioritized organizing against the nuclear programs of neighboring countries, especially Sweden. Together with Swedish Folkkampanjen mot kärnkraft (FMK) and like-minded Norwegians, OOA organized a sizable march in Sweden in September 1977. Over the following years, OOA published reports, organized demonstrations, and continued to demand the closure of the Barsebäck plant. Barsebäck illustrated the particularly high risk presented by nuclear facilities in densely populated areas. In 1985, this campaign motivated the Danish government to request that their Swedish counterparts close the Barsebäck plants. This eventually happened, but not until 1999 and 2005.

A Danish radio play by the name *Den menneskelig faktor* (The human factor) was broadcast in 1975. Tracing humanity's evolution from its origins to the current atomic age, it was written by Jesper Jensen and Per Schultz, with music by Benny Holst and Arne Würgler. The following year, the revue was incorporated into Benny

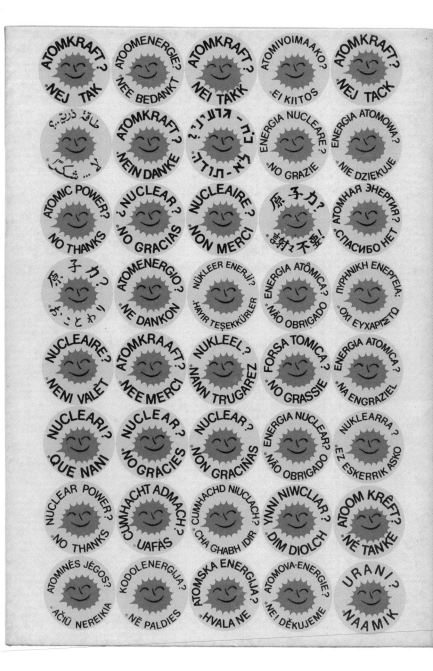

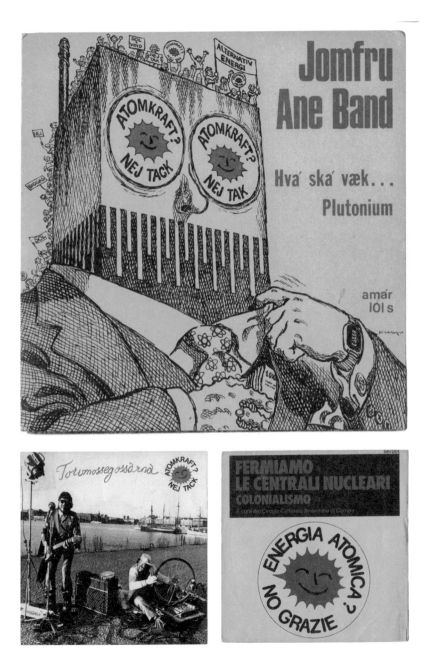

Following page spread, lefthand page, clockwise from top left: The Fourth Wall, *We Are the Guinea Pigs* 7", One Kind Favor, 2013; Resistance, *Survival Kit* 7", Fontana, 1981; Jorge Santana, *It's All about Love* LP, Tomato, 1980; Palace Flophouse, *Dodewaard* 7", Paladijn, 1980; Hets, *Uran* 7", Alternativ, 1979; Various artists, *Wehrt Euch!*, Verlag Arbeiterkampf, 1977.

Holst's band Agitpop's album *Den sidste olie: Sange om A-kraft og kapitalisme* (The ultimate oil: Songs of atomic power and capitalism), released on the explicitly socialist Demos label. Also in 1976, the OOA released its compilation LP *Atomkraft? Nej tak* (Nuclear power? No thanks), which included music from many important Danish musicians, including Agitpop and their labelmates Jomfru Ane Band, Gnags, Bifrost, Povl Dissing, and Gasolin'. The album opened with Gnags' "Sig nej, sig nej" (Say no, say no), which became a radio hit. The title and cover image of the record are taken from the "smiling sun" logo, which can also be found on other antinuclear records as well as on bumper stickers, posters, buttons, leaflets, and other antinuclear ephemera. It was designed in 1975 by twenty-one-year-old activist Anne Lund with input from others within the Organisationen til Oplysning om Atomkraft (Organization for Information on Nuclear Power, Denmark's largest antinuclear formation). In the original graphic, the words "Atomkraft? Nej tak!" (Nuclear power? No thanks!) circled the sun. This logo was taken up by other groups around the world and translated into over forty national and regional languages, becoming the most common symbol within the antinuclear power movement.

Jomfru Ane Band was a political Danish rock band that grew out of a 1960s experimental theater troupe of the same name. With twin sisters Rebecca and Sanne Brüel as iconic voices and faces, the band started in the mid-1970s and came to an end in 1982 after releasing a handful of albums and singles, with their final LP ending up on CBS Records. The first album, the self-titled *Jomfru Ane*, was recorded in 1976 and released the following year. It contains three songs about nuclear power: "Den Stummen Lakaj," "Balladen om A-kraft" and "Plutonium." "Plutonium" was rereleased at the height of the Swedish nuclear debate in 1980 as the B-side of the 7" single "Hva' ska' væk" (What's going on). The cover illustration features the smiling sun logo covering the eyes of an oversized businessman with a factory for a head while protestors occupy the roof. The liner notes explicitly condemn the Barsebäck nuclear power plant: "Today we

know that the Barsebäck plant . . . poses a constant threat to a population of millions in the most densely populated area in the Nordic region. We know that even the best contingency plan cannot secure us if the accident happens. And we know—after Harrisburg—that it can happen. There can no longer be any doubt: the Barsebäck plant must be closed."

OOA'S MOTTO: *ALDRIG GI'R VI OP!*

"Music played a huge role in OOA. We sang a lot, both when we marched and when we held meetings. Every national meeting ended with the same song, 'Et træ med dybe rødder' (A tree with deep roots), also called 'Aldrig gi'r vi op' (Never give up)," says Bente Meillier, an OOA activist.* The song, set to the melody of "We Shall Not Be Moved," gave unity, strength, and joy, and "Never Give Up" became the OOA's motto and slogan. A photobook about the great Danish antinuclear marches in August 1978 was also titled *Aldrig gi'r vi op*.

The tune "We Shall Not Be Moved" is a very well-known international protest song. It originated in the American South, a hymn written and sung by African American enslaved people. It was picked up and used as a slogan by the labor movement in the 1930s and 1940s and was at the core of the emerging civil rights movement in the 1940s and 1950s. In the late 1960s, protesters against Spanish dictator Francisco Franco sang "No nos moverán" at campus demonstrations, and during the Chilean coup against President Salvador Allende on September 11, 1973, it was the last song played on Radio Magallanes before the Chilean army raided the station and bombed the presidential palace. Pete Seeger helped repopularize the song as part of the civil rights movement of the 1950s and 1960s and later added several verses against nuclear power, as can be heard on the *Pete Seeger Singalong Demonstration Concert* LP, recorded live on January 11, 1980. It has been recorded by countless artists, including Joan Baez, Elvis Presley, Johnny Cash, and Ella Fitzgerald, and has been sung by millions. In the 1970s, Swedish troubadour Roland von Malmborg

* "Bevægelsen," on the website *Atomkraft? Nej Tak*, about the history of the OOA, accessed November 1, 2023, https://www.atomkraftnejtak.dk/bevaegelsen. Translated from Danish.

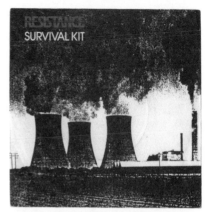

RESISTANCE
SURVIVAL KIT

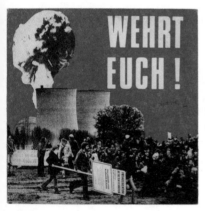

WEHRT EUCH !

Jorge Santana
It's All About Love

URAN

HETS

DODEWAARD
Palace Flophouse

achterhoekse
hymne

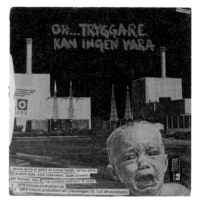

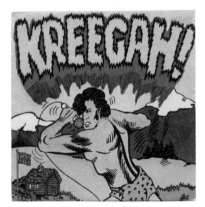

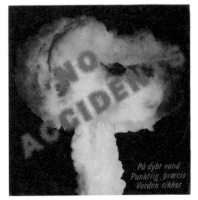

wrote a Swedish version about nuclear power and Barsebäck; it's titled "Aldrig ger vi upp" (Never give up). It became popular in the Swedish antinuclear movement and was translated into Danish, and this is how it found its way to the OOA. The song's simplicity and ubiquity make it easy to create new verses to fit new contexts.

SWEDEN: *VI KAN LEVA UTAN KÄRNKRAFT*

The first United Nations Conference on the Human Environment was held in Stockholm, Sweden, in June 1972. On June 7, the daily newspaper *ECO*, published by Friends of the Earth and the *Ecologist*, ran an article, "The Swedish Cover-Up on Nuclear Safety." It detailed how Olof Palme, the Swedish Social Democratic prime minister, opened the conference with remarks suggesting that an international energy policy should include "a substantial increase in units for conversion of nuclear energy to electricity." This was not well received, nor were revelations about his government's aspirations to develop nuclear weapons using civilian nuclear power as cover. Public debate followed. In 1973, Swedish Parliament halted all new planning of nuclear facilities until a "new non-biased basis for decisions" was presented. In effect, it was the world's first nuclear power moratorium. In 1975, the government presented legislated goals for a sustainable energy system. The main message was that the growth of nuclear energy should be slowed down and stopped at some point in the future, that research and development should be switched to alternatives, and that the planning of nuclear reactors be cut down on precautionary grounds. One interpretation of the bill was that its primary intention was to buy time, hoping that antinuclear sentiments would dissipate. Planning and construction of nuclear reactors slowed but continued.

As a contribution to the debate, a compilation album was released in 1975: *Vi kan leva utan kärnkraft* (We can live without nuclear power), on the Silence label. All the material was original to the record, which gathered some of the most important folk and progressive acts of the era. It also contained a contribution from Denmark by the arts and music collective Røde Mor.* The gatefold sleeve opened to

*See *Signal:02*.—Eds.

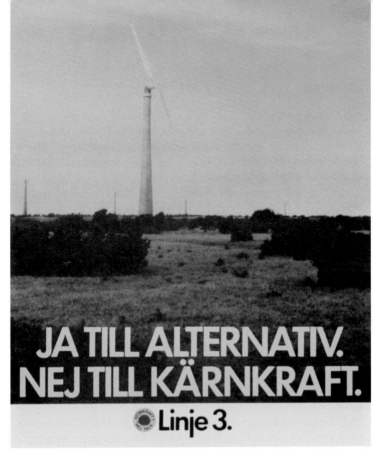

JA TILL ALTERNATIV. NEJ TILL KÄRNKRAFT.
Linje 3.

a wealth of information on alternative energy and the economics of nuclear power. In 1979, the umbrella organization Folkkampanjen mot kärnkraft (People's Campaign Against Nuclear Power) was formed, and it remains the leading national antinuclear organization in Sweden. In 1986, they added antimilitarism to their focus, becoming Folkkampanjen mot kärnkraft och kärnvapen (People's Campaign Against Nuclear Power and Nuclear Weapons).

SWEDISH REFERENDUM 1980

After years of massive opposition to Sweden's nuclear power program, the Swedish government agreed to hold a nonbinding

Strange Factory, *Fukushima Nightmare* 7", Hardcore Survives, 2014; Various artists, *What a Hell Fukushima* CD, Human Recovery Project, 2011.

referendum on nuclear power on March 23, 1980. The nuclear opponents united around a modest common ballot (Linje 3), demanding an end to all construction and a phasing out of the operating reactors within a decade. The other side divided into two positions, one for the Conservatives (Linje 1) and one in which the Social Democrats, Trade Union Confederation, and Liberals profiled themselves as the "middle way" (Linje 2). The two pronuclear positions agreed on allowing all reactors, including those under construction, to operate for the duration of their expected service life before ultimately phasing out nuclear power. The difference between the positions was that Linje 2 demanded governmental control over the major parts of the electricity sector as well as preparations for the coming phase-out. It blurred the distinction between "yes" and "no" but campaigned under the slogan "Phasing Out with Sense." In doing so, Linje 2 won a narrow plurality of the vote, receiving 39.1 percent of the ballots cast. Antinuclear Linje 3 came very close, with 38.7 percent. Linje 1, the most pronuclear position, turned out to be the least popular, receiving only 18.9 percent of the votes. Many concerts were organized in the months and weeks before the referendum. Although Linje 1 was the least popular ballot option, the long-term, postreferendum Swedish energy policy has most resembled it. Nuclear power plants remained in the hands of both the Swedish government and private firms, depending on the plant. Some have been phased out, but most haven't. High profits in hydroelectric generation were not excessively taxed.

JAPAN: FUKUSHIMA AND NO NUKES 2012

A few months after the March 2011 Fukushima Daiichi nuclear power plant disaster, a Tokyo-based DIY punk collective called Human Recovery Project put out a CD compilation titled *What a Hell Fukushima* featuring twenty-eight punk and hardcore bands. Profits from the sale of the CD and the accompanying zine benefited the ongoing humanitarian relief efforts in the Fukushima Prefecture. It was one of numerous recordings that called attention

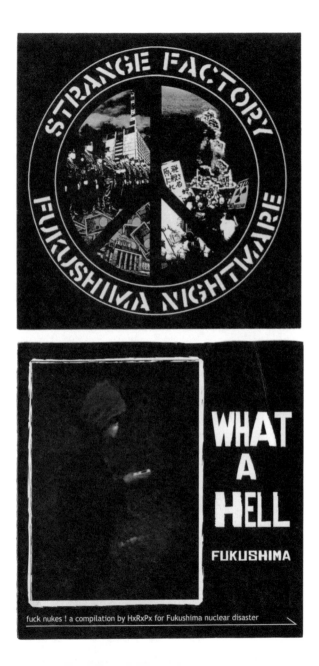

to the aftereffects of the earthquake and tsunami and the triple meltdown they caused. Some recordings criticized plant operators Tokyo Electric Power Company explicitly, while others, such as Little Masta's 2012 song "Divorce (Because of a Damaged Nuclear Plant)" (on the CD *Save the Children from Nuclear Pollution*) highlighted the human tensions that radiological accidents can produce: "Mothers are struggling to protect food supply from radioactive contamination / Fathers say, 'Don't be nervous, honey baby.'" As Little Masta's Bandcamp page explains, he moved his own family south to Okinawa to escape the geographically concentrated fallout of Fukushima and was perceived by some as overreacting. These are just two examples of post-Fukushima Japanese antinuclear music—anybody with even a passing interest should read Noriko Manabe's 2015 book *The Revolution Will Not Be Televised: Protest Music after Fukushima*, which highlights how cultural norms impact how antinuclear music is expressed, shared, and distributed in Japan. In categorizing and defining the various spaces of antinuclear music, she makes it easier to conceptualize differences between them. One such difference is the greater permanence of studio recording as opposed to the ephemerality of songs performed at demonstrations or music festivals, although this impermanence is complicated by recording technologies and the internet.

Let's briefly explore an example of live music being mobilized in the service of Japanese antinuclear politics. A year after the Fukushima disaster, the Japanese government was still deeply committed to nuclear power. Ryuichi Sakamoto, an Academy Award–winning composer and member of the Japanese technopop group Yellow Magic Orchestra, urged his fellow musicians to help him stage a concert aimed at ending nuclear power in Japan. No Nukes 2012 was held on July 7–8, 2012, in the Makuhari Messe Convention Center in Chiba, near Tokyo. Profits were donated to Sayonara Genpatsu 1000 Man Nin Akushon (Citizens' Committee for the 10 Million People's Petition to Say Goodbye to Nuclear Power Plants). The concert featured performances by eighteen groups,

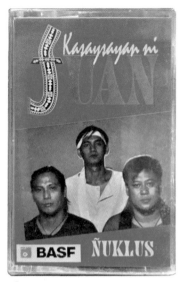

ÑukluS, *Kasaysayan Ni Juan* cassette, Aguilar Music Productions, Inc., date unknown.

including German electronic innovators Kraftwerk and Yellow Magic Orchestra, as well as rock bands Asian Kung-Fu Generation, Acidman, and others. A CD with a selection of Yellow Magic Orchestra's contributions—they performed on both days—was released in 2015.

PHILIPPINES: CONFRONTING THE MONSTER OF MORONG

In the Philippines in 1976, dictator Ferdinand Marcos ordered a nuclear power plant from the US firm Westinghouse in response to the OPEC oil embargo. The deal that gave birth to the Bataan Nuclear Power Plant (BNPP) was surrounded by rumors of bribery, with Marcos believed to have personally made $80 million from the transaction. Construction began in 1979; when Bataan was finally finished in 1984, the $2.2 billion price tag was over four times the initial estimate. In August 1985, an explosion in the oxygen gas system during the test phase delayed the plant's opening. The Marcos dictatorship was overthrown the following year. Taking the Chernobyl accident to heart, newly elected president Corazon Aquino mothballed the plant in November 1986.

ÑukluS, formed in Manilla in 1979, was a band with an initial focus on spiritual music. Soon ÑukluS started to write songs that were more socially and politically engaged. They took inspiration from the struggle against the Bataan Nuclear Power Plant. Composed in 1980 and first sung at their Konsyerto Laban Sa Polusyon (Concert at the Park), the song "Dambuhala Sa Moron" (Monster of Morong) was adopted as a theme song by the no-nukes movement headed by the Nuclear-Free Philippines Coalition. In 1983, they played in a rock

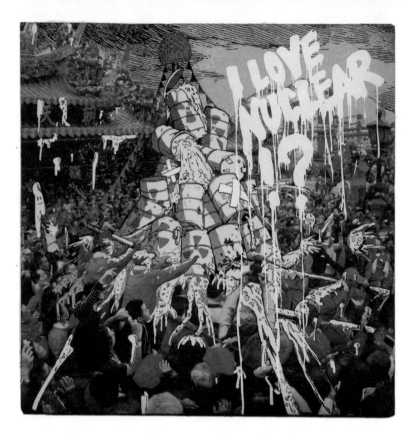

opera titled *Nukleyar* with the Philippines Educational & Theatrical Association. In 1984, ÑukLuS, together with other artists, started an organization called BUKLOD (Bukluran ng Musikero para sa Ikauunlad ng Bayan, or Musician's Association for the Development of the People) to educate about the oppressive Marcos regime. In June 1985, after winning a music competition, they released their first single, titled "Mamang May Baril" (Mama has a gun). The song tackled the militarization of the country and was denied radio play. After the People Power Revolution in 1987, the group disbanded.

In May 2022, Ferdinand Marcos Jr., the son of dictator Ferdinand Marcos, was elected president, and he said he was keen to revive the Bataan nuclear project.

TAIWAN: FINANCING THE MOVEMENT WITH MUSIC

In Taiwan, the rise of the antinuclear movement is closely re-
lated to the democratization process. The Democratic Progressive
Party adopted an unequivocal antinuclear stance at its founding in
1986. Prior to that, the only major antinuclear activity in Taiwan
took place on Orchid Island, led by aboriginal Tao people against
a nuclear waste storage facility for Taiwan's three nuclear power
plants that was built without permission in 1982. (This waste facility
remains in operation, and protests continue.) The election victory
of the Democratic Progressive Party in the year 2000 ended over
fifty years of autocratic rule by the Kuomintang party, and protests
against Taiwan's nuclear program became more mainstream.

In December 2012, the Taipei-based DJ collective Soundfarmers
released an electronic music compilation titled *I Love Nuclear!?* It was the
first antinuclear album released in Taiwan. The avant-garde millennial
artist Cheng Ye-Ping, also known as Betty Apple, was behind the disc.
Apple cofounded Soundfarmers and has long been concerned about
nuclear waste, the environment, and postcolonial politics in Taiwan.
Soundfarmers describe the music on *I Love Nuclear!?* as "Distorted
sounds, exploding beats, acid ambience, twisting ears and grooving bod-
ies. . . . This is a compilation . . . foregrounded against nuclear power
as well as the craziness and absurdity revolving around it. . . . Nuclear
power exemplifies such a fetish of modern society for technology." All
profits from the album and release party were donated to the Green
Citizens' Action Alliance (GCAA) for antinuclear purposes. In the face
of the government's appetite for nuclear power, the GCAA was the
main force behind another compilation, a double CD called *No Nukes!
Long Play!* released in December 2013. The compilation includes thirty-
four rock, rap, waltz, and folk songs in both Mandarin and Taiwanese.

ANTINUCLEAR STREET THEATER, POLITICAL STREET BANDS, AND "ISSUE-ORIENTED ENTERTAINMENT"

The antinuclear movement has been home to a variety of musicians
and performers who came from a musical theater background or

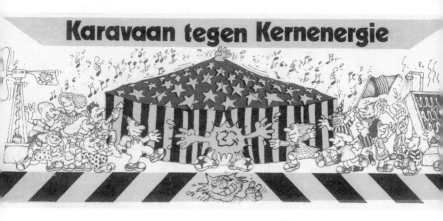

Karavaan tegen Kernenergie

who incorporated elements of street theater into their musical presentation. Some of these convened specifically for the purpose of sharing antinuclear culture, while others tackled nukes as part of a larger social critique. Dutch group Proloog is an example of an ongoing street theater project addressing a wide variety of issues, including nuclear power. The Toneelwerkgroep Proloog Foundation was founded in Eindhoven, Netherlands, on September 17, 1964. Proloog provided introductory arts lessons and multiple forms of theatrical training. They emphasized youth theater and performance in nontraditional theater spaces like community centers and factory halls. Their 1981 LP, titled *Kernenergie nee bedankt* (Nuclear power no thanks) is a recording of their antinuclear performance *Wij zijn niet af te koelen* (We can't cool down). The play was produced in collaboration with the Eindhovense Stroomgroep Stop Kernenergie and the Belgian Stop Atoomplannen Kempen working group, and the record was released by a small folk label called Peace Pie. The program was played at meetings preceding the demonstration in Mol (Belgium, October 25, 1980) and at the blockade of Dutch nuclear power plant Dodewaard in the same month. Afterward, it continued to be performed for young audiences in schools, work centers, and elsewhere. Proloog's follow-up was also a theater performance about nuclear power: *Waarom de hond zijn baas verliet* (Why the dog left its master). This went unrecorded. Proloog was one of the initiators of the Karavaan tegen Kernenergie (Caravan Against Nuclear Power). For a couple of weeks in the summer of 1982, a complete roadshow

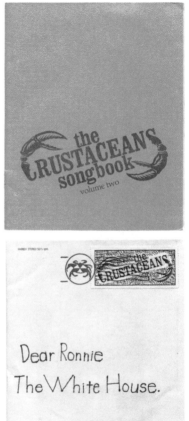

traveled from one tourist destina-
tion to another, playing several
days at every stop on the tour.
The roadshow attractions in-
cluded acrobats, Punch and Judy,
pop music, theater, art exhibits,
and lectures. Unfortunately, no
official recordings and very few
pictures document this large pro-
duction of antinuclear culture.

Shelly and the Crustaceans
(later simply the Crustaceans)
were a Seattle, Washington, in-
dependent performing collective
who employed consensus-based,
nonhierarchical, antisexist de-
cision-making to present their
"issue-oriented entertainment"
against nuclear power and nu-
clear weapons. From 1977 until
1985, they performed antinuclear
music at demonstrations, includ-
ing those against the Satsop
Nuclear Plant in Washington and
the Diablo Canyon Power Plant
in California. The Crustaceans
performed mini rock operettas
while dressed as crabs and covered antinuclear standards, including
Malvina Reynolds's "Power Plant Reggae." They also adapted the fa-
miliar melodies of popular Motown and Beatles songs as a vehicle for
antinuclear content. As time passed, the Crustaceans began to write
more of their own material, releasing their *Dear Ronnie 7"* EP in
1983. The four-song single takes the appearance of a letter, with the
title acting as the address and the band name occupying a beautiful,

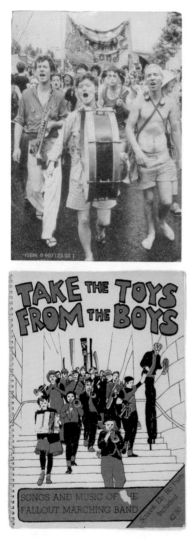

three-colored stamp affixed to the upper right corner. Rounding out the postal theme is a hand-stamped faux cancellation mark featuring the Crabshell Alliance's symbol, a crab bearing a radiation warning logo. Naturally, the subject of *Dear Ronnie* was US president Ronald Reagan. Although these four songs were the only ones to make it to vinyl (the song "Dear Ronnie" also made it onto Fuse Records' *Reaganomics Blues* compilation a year later in 1984), the Crustaceans did publish two songbooks during their existence. Moreover, because they simultaneously operated an audio-visual production team called High Hopes Media, some Crustaceans performances and direct actions were recorded on analog video. In one particularly memorable video, Shelly (the Crab) and her various Puget Sound animal friends, including Starfish, Geoduck, and Owl, visit the state capitol to meet with notorious nuke-booster Dixy Lee Ray, then governor of Washington. The animals interrogate Ray on what she is doing to protect their habitat. Ray was a popular target. In their first songbook, the Crustaceans explain that their song "Nuke-A-Lady Dixy," set to the tune of "Ukulele Lady," describes a politician who "is not [only] a local disease . . . [but] a

The Fallout Marching Band, *The AntiNuclear Songbook: The Peace News Pamphlet* (back cover), no. 3, 1982; *Take the Toys from the Boys: Songs and Music of the Fallout Marching Band*, Fallout Marching Band, 1985.

symbol of an international threat." They end the song with the words, "We don't need tankers or greedy bankers / To ruin what we've got / But most of all we don't need Dixy / To nuke us till we're hot."

London's the Fallout Marching Band had much in common with the Crustaceans, including a song addressed to Ronald Reagan ("Hey Mr. Reagan"), a highly democratic process of collaboration, and a focused musical repertoire directed against the intertwined threats of nuclear power and nuclear weapons. Nevertheless, their approach was somewhat different from the Crustaceans. The Fallouts, who still play from time to time and now count a few of their children as members, consider themselves a "political street band." Similar bands proliferated across Europe during the early to mid-1980s, often providing a spirited soundtrack for antinuclear mobilizations. The Fallout Marching Band played their first gig outside a Royal Institute of British Architects symposium devoted to the topic of building nuclear bunkers for the wealthy. As member Will Embliss puts it, they continued evolving as "a loose collective of musicians from many walks of life with a very varied range of musical experience and abilities." Any given event could turn out anywhere from four to thirty members. In addition to playing up to fifty gigs a year for the Campaign for Nuclear Disarmament, the Fallout Marching Band played at a demonstration against the Sizewell nuclear reactor and performed at the Greenham Common Women's Peace Camp. Founding member Jennifer Peringer even lived at Greenham for a time, helping to organize "The First National Anti-nuclear Bands' Conference" in 1982, a DIY primer on how to form one's own street band. Early on, members began face painting, providing striking images that got the band—and the issues that were important to them—into the national press. The Fallouts took this to the next level by incorporating street theater into their performances, ending their song "March of Impending Doom" on the ground, immobile. They did a theater piece on nuclear waste at Glastonbury. Two of their songs, "Take the Toys from the Boys" and "Chant Down Greenham," became movement classics, and a handful of others critiqued nuclear

IMAGINE
OF
THREE MILES IS. U.S.A.
CHERNOBYL U.S.S.R.
WINDSCALE U.K.
AND
NEXT?

energy specifically. A few of their compositions turned up in *Peace News Pamphlet*'s *The Anti-nuclear Songbook* (1982). The band also published their own songbook in 1984.

CONCLUSION

As the zeitgeist of the moment passed, and singularly focused musicians like the Fallout Marching Band and the Nuclear Regulatory Commission began diversifying their songbooks, we arrive at a point of transition. After peaking in the late 1970s and early 1980s, the antinuclear movement declined, and many politically oriented musicians felt it was necessary to recalibrate. From our present vantage point, we can observe that antinuclear music, like the activism it follows from, has always been somewhat cyclical, growing in response to threats and calamities of the moment, then shrinking while never going away entirely. This was true of the antibomb music from the first Cold War, and it is equally true of the antireactor music of the 1970s and early 1980s.

Given humanity's appetite for profiting from nuclear power and nuclear proliferation, we are never far from another catastrophe, that much is certain. Like some sort of culturally calibrated Nuke Buster, the extant discography of antinuclear music always registers the upticks in awareness and activism that follow. Chernobyl was an excellent example of this, coming just a few years after the peak of the antinuclear movement and setting off a whole new cycle of music. As Motoharu Sano asks on the cover of his 1988 post-Chernobyl single 警告どおり 計画どおり (As warned, as planned): "And next?" As of this writing, there have been several near misses at Ukraine's Zaporizhzhya facility from active combat in proximity to Europe's largest nuclear plant. Meanwhile, on September 2, 2022, the California State Legislature voted to relicense the badly embrittled

Diablo Canyon Power Plant, providing plant operators PG&E with a $1.6 billion handout, taxpayer money that should, but won't, be used for renewables. Considering that California is facing a near certainty of a major earthquake in the next few decades, is this even remotely sensible? Of course, not even the worst reactor accident compares in scale to the omnipresent risk of a terminal nuclear war. Given the moral caliber of our elites and the loosening of taboos around nuclear weapon use, the doomsday clock ticks dangerously onward.

Even in the absence of nuclear fallout, the passage of time and an increasingly volatile, collapsing climate present abundant risks to the material culture of human endeavor. Antinuclear artifacts and ephemera are no exception. Collecting rare and scarcely produced recordings is challenging enough, but how do we preserve these materials for future audiences, especially without institutional support? How do we make potential audiences aware of these legacies and find ways for them to engage with the histories, ideas, art, and music inherent to these movements? And finally, how do we account for the instability of digital materials, which we have only barely addressed in this article but will be endemic issues for much of the present and future of antinuclear music? As archivists, we grapple with these issues to the best of our abilities and resources. Reality demonstrates that far from being anachronistic or quaint, antinuclear politics are more relevant now than ever. As elites and corporate media promote nuclear power as our climate salvation, we can count on musicians to continue offering counternarratives of resistance. As the American folksinger Charlie King said many years ago, "If there is a people's movement, there will be singing because the newspapers don't always tell the whole story." **S**

ADDITIONAL RESOURCES
ONLINE

Fitz Music. "The Yellow Cake Revue." YouTube, November 16, 2020. Video, 28:25. https://www.youtube.com/watch?v=QZbL4ySg7Ic. This is a video of Sir Peter Maxwell Davies's *Yellow Cake Review* as performed in 2020 at Fitzwilliam College, Cambridge.

High Hopes Media. YouTube channel. https://www.youtube.com/channel/UCkQHrEa98O6JrkYZ_Qg5QFA.

Kernes, Susan, and Kori Kody, producers. "The Energy Will Flow: Anti-nuclear Music by Women." KPFA radio program. 58:23. Internet Archive. Accessed November 1, 2023. https://archive.org/details/pacifica_radio_archives-AZ0450.

King, Charlie, and Luci Murphy. "A Brief History of the People's Music Network for Songs of Freedom and Struggle." People's Music Network for Songs of Freedom in Struggle. Accessed November 1, 2023. https://www.peoplesmusic.org/Our-History.

London CND. "Music as Direct Action." YouTube, May 12, 2021. Video, 1:06:25. https://www.youtube.com/watch?v=rQtibg5UBxQ.

"Music from the Antinuclear Movement." Laka Foundation. Accessed November 1, 2023. https://www.laka.org/music-from-anti-nuclear-movement.

"No Nukes: How NZ Music Helped Us Ban the Bomb." *Musical Chairs*, June 8, 2012. Podcast, 23:11. https://www.rnz.co.nz/national/programmes/musicalchairs/audio/2530442/no-nukes-how-nz-music-helped-us-ban-the-bomb.

"Radioactive Releases: The Music of Three Mile Island." Tapewrecks. March 15, 2014. https://tapewrecks.blogspot.com/2014/03/radioactive-releases-music-of-three.html.

Women's Liberation Music Archive. Website. Accessed November 1, 2023. https://womensliberationmusicarchive.co.uk.

ADDITIONAL RESOURCES
BOOKS

Dickerson, Carrie Bigfoot. *Aunt Carrie's War against Black Fox Nuclear Power Plant*. Tulsa, OK: Council Oak Publishing, 1995.

Frank, Joshua. *Atomic Days: The Untold Story of the Most Toxic Place in America*. Chicago: Haymarket Books, 2022.

Manabe, Noriko. *The Revolution Will Not Be Televised: Protest Music after Fukushima*. New York: Oxford University Press, 2015.

Wellock, Thomas Raymond. *Critical Masses: Opposition to Nuclear Power in California, 1958–1978*. Madison: University of Wisconsin Press, 1998.

Wilcox, Fred, ed. *Grassroots: An Anti-nuke Sourcebook*. Trumansburg, NY: Crossing Press, 1980.

ADDITIONAL SPINS ON SEAN'S NO-NUKES JUKEBOX

1. Greenpeace, "Anchor Me" (2005). Marking the twentieth anniversary of the bombing of the *Rainbow Warrior* by the French Secret Service, this cover of the Mutton Birds hit single features vocals by Hinewehi Mohi, Kirsten Morelle, Che Fu, Anika Moa, and several other New Zealand musicians. Don't miss the music video, which intercuts dazzling animation and treated archival footage and is easily found online.

2. Courtney Dowe, "Radiation Blues" (2011). Originally written by Ellen Thomas, an activist who maintained a peace vigil in front of the White House for nearly two decades, this song was updated by Washington, DC, singer-songwriter Dowe in 2011.

3. Serious Bizness, "The No Nuke Song" (1982). Jaribu and Ngoma Hill described their music as being "for people who never get enough to eat." Following from this, they rightly locate nuclear power as one more manifestation of the capitalist death system, which "brought you Hiroshima, cancer and emphysema." This track is from their 1982 Folkways LP, *For Your Immediate Attention*.

4. Peggy Seeger, "Take the Children and Run" (1982). This track is one of a couple Don Lange covers on US expatriate singer Seeger's 1982 album *From Where I Stand: Topical Songs from America and England*. Seeger, one of the most important English-language folk singers of the last century, wrote or cowrote with husband Ewan MacColl numerous antinuclear protest songs, including "The Invader," "Sellafield Child," and "The Plutonium Factor." While this song has been covered multiple times, Seeger's version is, to my ears, definitive.

5. Turn-Ups, "Radioactive Baby" (1982). This ground-zero reaction from

Clockwise from top left: First Light, *Meltdown!* 7", Thin Ice, 1987; Area, *Caution Radiation* LP, Cramps Records, 1974; Various artists, *Anti-Nuclear 12" Single*, Alternative Energy Records, 1979; Various artists, *Nej Till Kärnkraft!* LP, MNW, 1979; Devo, *Working in a Coalmine* 7", Virgin, 1981; The Zips, *Radioactivity* 7", Tenement Toons, 1980.

the Harrisburg punk underground sounds like it was recorded inside the Three Mile Island Unit 2 decommissioned cooling tower. Fortunately for the band's chromosomes, it wasn't. Issued on their 1983 album *Urban Blight* and available on YouTube as a live performance.

ADDITIONAL RECORDINGS (NONEXHAUSTIVE) FROM DIRK

1. Gerd Schinkel, *Atom & Strom* (2019). One of the most prolific antinuclear performers in Germany since the 1970s. This three-CD set collects his later antinuclear work.

2. Kraftwerk, "Radioactivity" (1991). A 7" single containing an antinuclear remix of the 1975 original, this one for the Stop Sellafield campaign.

3. Super Raelene Bros., "Nuclear Kop" (Redgum cover, 2011) and "Wiya Angela Pamela" (2010). Recent Australian work supporting the struggle against uranium mining.

4. The Austrian antinuclear movement was very much intertwined with cultural expression, mostly related to the struggle against Zwentendorf, which resulted in the antinuclear victory in the November 1978 referendum on the use of nuclear power. A few albums (Various artists, *1. Österreichische Anti-Atomkraftwerksplatte*, 1977; Various artists, *Künstler gegen Zwentendorf*, 1979) and a number of singles shouldn't be ignored.

5. Various artists, "Musicians against Nuclear Power" (2002). A compilation album in solidarity with Russian NGO Ecodefense, the main antinuclear organization in Russia and the subject of increasing repression.

THANK-YOUS

Dirk: Aernschd Born, Wilfried Staake, Siegfried Christiansen, Bente Meillier, Gerd Schinkel, and Basil Schild.

Sean: Tom Dotzler, Elizabeth Dotzler, B. Parker Lindner, Alan Fox, Brownie MacIntosh, Charlie King, Ted Warmbrand, Jennifer Peringer, Will Embliss and the Fallout Marching Band, Pat Scanlon, Bonnie Lockhart, Jeanne Mackey, Penny Rosenwasser, Tom Quinn, Genevieve Maxwell, and Sean O'Neill of Spit Records.

MELTDOWN! FIRST LIGHT

CAUTION RADIATION AREA

RADIOACTIVITY
THE ZIPS

ANTI-NUCLEAR

CHRISTY MOORE, BARRY MOORE, EARLY GRAVE BAND, DONAL LUNNY, MICHEAL O'DOMHNAILL, DECLAN SYNNOTT, RITA CONNOLLY, BASIL HENRIQUES, ANDY IRVINE, JIMMY FAULKNER, KEVIN BURKE, DECLAN McNELIS, ROBBIE BRENNAN.

12" SINGLE

Special Limited Edition No. 1

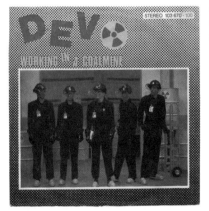

DEVO

STEREO 103 670 - 100

NEJ
TILL KÄRNKRAFT!

Lill Lindfors
Anders Linder
Monica Dominique
Ola Magnell
Marie Bergman
Robert Broberg
Dag Vag
Monica Törnell
Bernt Staf
Lasse Tennander
Hjördis Petterson

CONTRIBUTORS

Dirk Bannink is a founding member of Laka Foundation, a documentation and research center on nuclear energy, based in Amsterdam. He has been involved in the Dutch antinuclear movement since the 1970s and was editor in chief (1995–2010) of the *Nuclear Monitor*. In 2011, he compiled six hundred posters from the global antinuclear movement for the publication *Radiating Posters*.

Alec Dunn is an illustrator, a printer, and a nurse living in Portland, Oregon. He is a member of the Justseeds Artists' Cooperative.

Sean P. Kilcoyne is a film archivist, projectionist, and union organizer based in Los Angeles. He grew up several miles from Three Mile Island and experienced the meltdown as a six-year-old child.

Alex Lukas was born in Boston and raised in nearby Cambridge, Massachusetts. With a wide range of influences, his practice focuses on the intersection of place, human activity, narrative, and history through printed publication series, sculpture, drawing, audio, and video. Lukas is an assistant professor at the University of California, Santa Barbara, where he teaches print and publication in the Department of Art.

Josh MacPhee is one of the founders of Interference Archive, organizes the Celebrate People's History Poster Series, and is a member of the Justseeds Artists' Cooperative.

Aaron Terry grew up as a kid with no electricity or running water in the woods of upstate New York until fate brought his family to Philadelphia, where he grew into the city as a young adult. His biggest fear as a child was nuclear war or a bear attack. He is an assistant professor at the University of Delaware in the Department of Art and Design, where he teaches printmaking.

Davide Tidoni is an artist working from the boundaries of physical, perceptual, and affective dimensions of sound. His work addresses questions regarding interactions with acoustic space, interdependence, and impermanence. His practice also includes interests in the use of sound in countercultures and social contexts of struggle. He published *The Sound of Normalisation* (2018), a field research on the ultras group Brescia 1911, and *Where Do You Draw the Line Between Art and Politics* (2021), a series of interviews with individuals active at the intersection of art and politics.

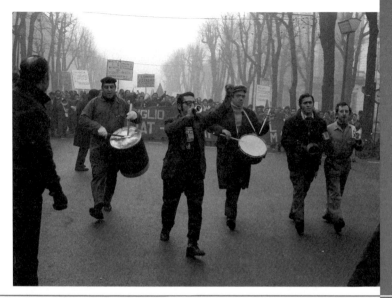

Photos of a 1979 Fiat workers demonstration, Turin, Italy. Photos by Raffaele Santomauro, courtesy of Pietro Perotti.

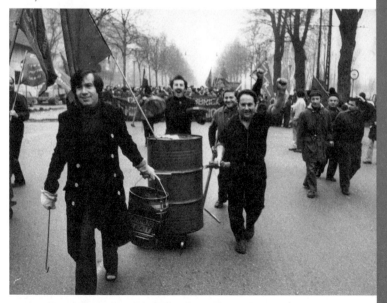

SIGNAL:07 Philadelphia Printworks • The Records of Victor Jara • Argentina's Estación Darío y Maxi • Book Arts of the Situationist International • Poster Artist and Muralist Malaquías Montoya • Belgian Expressionist Albert Daenens • Posters of the Catalan Left

SIGNAL:08 Dread Scott's Slave Rebellion Reenactment • *Liberation Magazine* and the Cover Art of Vera Williams • Memorializing Victims of Anti-Sikh Violence • Travel Documents of a PFLP Hijacking • The Book Designs of the Black Power Movement

SIGNAL:09 An Interview with Italian Art Agitator Pietro Perotti • The Music of the International Antinuclear Power Movement • Print on Demand Technology and the American Right • Liberatory Movie Posters of the Soviet Bloc

"For everyone interested in the expression, repression and expansion of politics through mass communications and design, all eight issues of *Signal*—and those to come— are invaluable resources."

—Steven Heller
Print

PM Press is an independent publisher of critically necessary books and other media—by radical thinkers, artists, and activists—for our tumultuous times. Our aim is to deliver bold political ideas and vital stories to all walks of life and arm the dreamers to demand the impossible. Founded in 2007 by a small group of people with decades of publishing, media, and organizing experience, we have sold millions of copies of our books, most often one at a time, face to face. We're old enough to know what we're doing and young enough to know what's at stake. Join us to create a better world.

PM PRESS
PO Box 23912
Oakland CA 94623
510-658-3906
www.pmpress.org

PM Press in Europe
europe@pmpress.org
www.pmpress.org.uk